PRECOLUMBIAN ART
OF NORTH AMERICA AND MEXICO

PRECOLUMBIAN ART
OF NORTH AMERICA AND MEXICO

General Editor
Francesco Abbate

Translated by
Elizabeth Evans

Octopus Books

London · New York · Sydney · Hong Kong

English version first published 1972 by
Octopus Books Limited
59 Grosvenor Street, London W1
Translation © 1972 Octopus Books Limited

Distributed in Australia by
Angus & Robertson (Publishers) Pty Ltd
102 Glover Street, Cremorne, Sydney

ISBN 7064 0030 5

Originally published in Italian by
Fratelli Fabbri Editore
© 1966 Fratelli Fabbri Editore, Milan

Printed in Italy by Fratelli Fabbri Editore

CONTENTS

ESKIMO ART

It is believed that the ancestors of the American Eskimo and Indian peoples originated in Asia, and then at a very early period some 20–25,000 years ago migrated in a series of waves across the Bering Sea to the northern regions of America. Although these peoples shared a common Mongoloid racial heritage, they were already separated into groups of differing linguistic traditions and in time they developed highly distinctive cultural traits as they became settled in their new lands.

Alaska and the coastal areas of Canada and Greenland subsequently became the second homeland of the mysterious Eskimo race; it is here that the earliest remains of their culture have been found, dating back to the fourth or fifth century BC. This was in fact the time of the oldest period, the Okuik, of what is known as the Bering Sea culture. There followed the Ipiutak, Birnik and Pununk periods. These lasted until the thirteenth century AD, during which time there was little change in the basic characteristics of Eskimo art

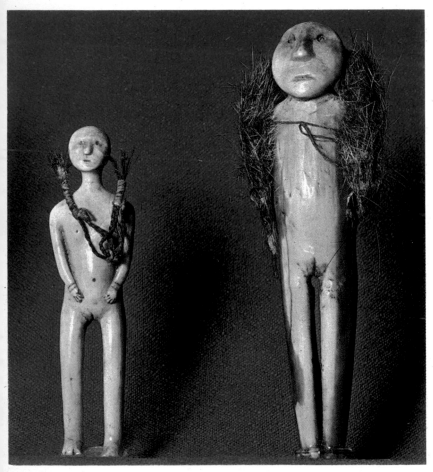

1 *Alaskan Eskimo art : Bone figurines of women. Museo Pigorini, Rome.*

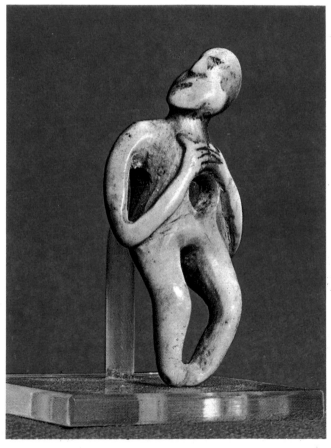

2 *Alaskan Eskimo art : Bone anthropomorphic pendant.*
Museo Pigorini, Rome.

1–2 Alaskan Eskimo art: *Bone figurines of women* (left) and *a bone anthropomorphic pendant charm.* Museo Pigorini, Rome.
The only surviving examples of Alaskan Eskimo art are ivory and bone figurines that had some unknown ritual significance, and trinkets and simple pendants. The tentative style of these early objects often gives them a surprising strength.

3 Eskimo art: *Painted driftwood.* United States Department of the Interior Museum, Washington, DC.
The way this work is drawn, the use of colour and natural forms instead of linear motifs, and the flow of the composition all show great technical skill.

3

4–5 Eskimo art: *Wooden masks*. Nationalmuseet, Copenhagen (left), Private Collection, Milan (right).
Masks are the most common objects in Eskimo art. Some are made with grotesquely distorted faces decorated in strident colours and with pieces of skin or bone added; others are stylized according to an almost geometric design, while yet others represent quite faithful portrayals of the human face.

6 Eskimo art: *Wooden mask*. Nationalmuseet, Copenhagen.
Masks had many uses, not all of them known, but they were certainly used at religious or funeral ceremonies and dramatic performances.

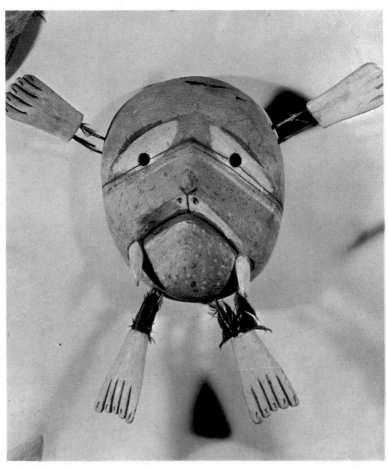

4 *Eskimo art : Wooden mask. Nationalmuseet, Copenhagen.*

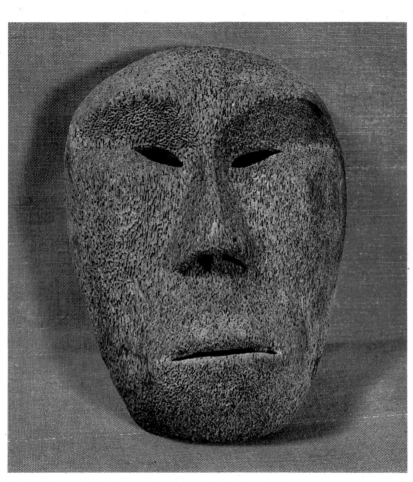

5 *Eskimo art : Wooden mask. Private Collection, Milan.*

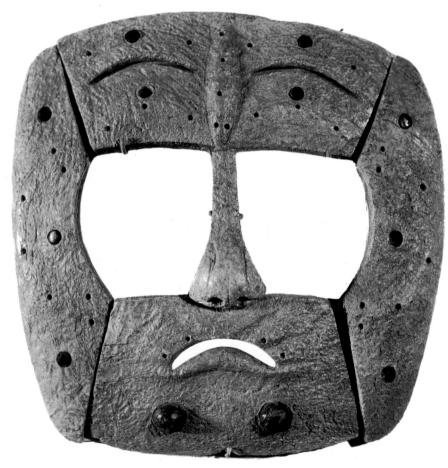

6 *Eskimo art : Wooden mask. Nationalmuseet, Copenhagen.*

style and workmanship. They were a nomadic people and consequently left no buildings; their output was limited to objects of daily use, including masks and toys. These are all quite small and are generally made from bone, wood or ivory, with minute calligraphic decoration. They are characterized by a very simplified and yet refined design, which is also extremely elegant and occasionally features curvilinear or circular decorative motifs (Bering Sea culture) or small carvings mostly of zoomorphic subjects (Ipiutak period).

Ornamental motifs were modified during the Pununk period that developed on Saint Lawrence and the Diomede Islands; these became increasingly rigid and stylized as a result of the introduction of iron tools and, possibly, from Siberian influence. Modern Eskimo art is probably inspired by the style of this period, although it has of course also absorbed elements of European culture, among them a greater interest in realism in contrast to the traditional Eskimo preference for abstract forms. There is a typical form of modern Eskimo carving that is finely incised and often embellished with colour and gives a kind of shorthand account of daily life.

Masks, generally in wood, are of special interest. They were used either in religious ceremonies or for entertainments such as plays or farces; they tended to be small because wood was difficult to obtain (only driftwood from rivers and the sea was normally available). Feathers, rings and small symbolic objects were added to the masks to make them more impressive.

NORTH AMERICAN INDIAN ART

The vast region of the Pacific coastlands, isolated from eastern America by the Rocky Mountains, stretches from Yakutat Bay in South Alaska to the Columbia River in Oregon. It is the home of the artistically important culture of the North-West Coast Indians. Because of the abundance of fish in the coastal waters and the fertility of the land the Indians enjoyed a stable and prosperous economy and could afford to look after their spiritual as well as their material needs. Thus, besides crafts such as basketwork and weaving they produced genuine works of art for purely aesthetic ends. Sculpture was the chief artistic activity, judged both by quality and quantity; drawing and painting must have been considered of lesser significance and were normally used only to decorate carvings.

Typical also of North-West Coast Indian art are the masks and totem poles that played an important part in the customs of this society. The totem poles were made of tree trunks and were generally about thirty to forty-five feet high, and covered with paintings and carvings. Contrary to the meaning of the word (*totem* = deity) the poles had no religious significance but were in fact heraldic devices used by individual families; a traditional totemic animal was adopted by the family as a crest and used to relate their history or any particularly important event. The erection of a new totem pole was the occasion for solemn ceremonies that included the *potlach* – a bizarre and extravagant feast at which the chiefs of leading families competed for

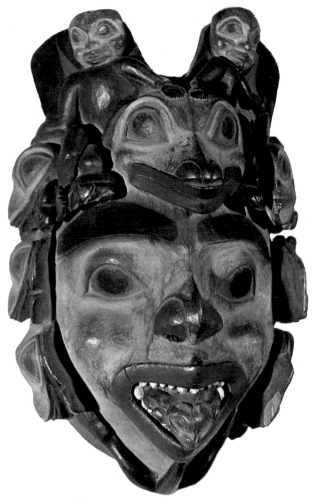

7 *Indian North-West Coast art : Spirit mask from Point-Lena*
(Alaska). 1825–75. Museum of the American Indian, New York.

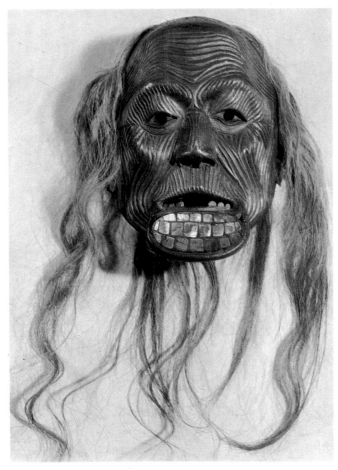

8 *Indian North-West Coast art, Niska culture : Wooden mask. 1825 50. Museum of the American Indian, New York.*

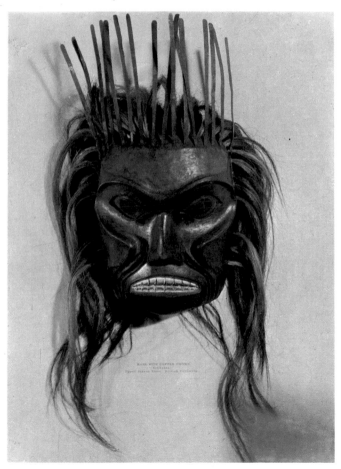

9 *Indian North-West Coast art, Kitiksan culture : Mask with copper crown. Museum of the American Indian, New York.*

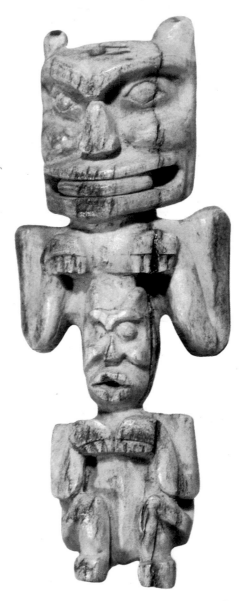

10 *Indian North-West Coast art, Tlingit culture : Bone
carved with figures. Museum of the American Indian, New
York.*

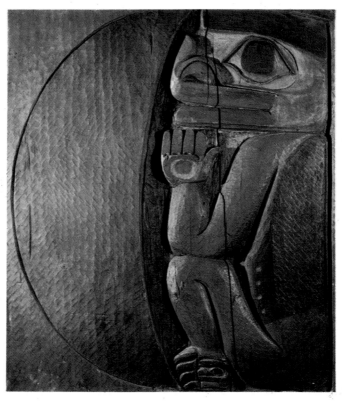

11 *Indian North-West Coast art, Tlingit culture : Incised and
painted wood panel. Museum of the American Indian, New
York.*

7 Indian North-West Coast art: *Spirit mask* from Point-Lena (Alaska). 1825–75. Museum of the American Indian, New York.
This richly decorated ritual mask has an otter on the spirit's forehead; a toad is emerging from its mouth and other toads surround the face.

8 Indian North-West Coast art, Niska culture: *Wooden mask*. 1825–50. Museum of the American Indian, New York.

This is not a stylized mask but a real portrait. Tufts of hair add to the rather gruesome image, and a curious mosaic is set into the chin.

9 Indian North-West Coast art, Kitiksan culture: *Mask with copper crown*. Museum of the American Indian, New York.
The face is furrowed with deeply incised lines to make the image more awesome.

10 Indian North-West Coast art, Tlingit culture: *Bone carved with figures*. Museum of the American Indian, New York.
The merging of animal and human forms is a typical theme of primitive art.

11 Indian North-West Coast art, Tlingit culture: *Incised and painted wood panel*. Museum of the American Indian, New York.
The large moon on the left of the composition reflects a belief in lunar powers.

12 Indian North-West Coast art: *Prehistoric rock carving*. Museum of the American Indian, New York.
This rock engraving probably indicated a path or boundary.

12 *Indian North-West Coast art : Prehistoric rock carving. Museum of the*
American Indian, New York.

tribal honour, the status of the host being determined by the lavishness of the gifts with which he overwhelmed his guests. The more ostentatiously wasteful he could be, the greater the power he asserted in the tribe.

Two curious religious objects are of interest for their fine carving and engraving: the wooden rattle and the soul box. The precise ritual function of the former is unknown, but the soul box resembles a small case or scabbard and was used by the *shaman* (the person who was known in the community to have magic powers) to contain the soul of a sick man as it strayed from his body.

The original settlers in the North American continent are traditionally divided into six cultures corresponding to the major linguistic and geographical regions. In addition to those already discussed – the Arctic Eskimos and the North-West Coast Indians – there are the Indian cultures of California and the Great Basin, the South West, the Great Plains and the Eastern Woodlands.

The tribes of California and the Great Basin, extending into parts of Oregon, Utah and Nevada, are best known for the technical mastery and variety of their basket weaving. Typical baskets were conical and spherical in shape and in size varied between three feet across and miniature versions hardly larger than a thumbnail; they were decorated with stylized designs of plants and animals and with geometric shapes.

The ancient art of the South-West region is domi-

nated by Pueblo painted pottery – bowls and jars decorated with abstract representations of plant and animal forms, occasionally of human figures, too. The Pueblo was primarily a graphic culture: in prehistoric times underground ceremonial chambers (*kiva*) were decorated with large polychrome paintings; the Pueblo Indians also produced brightly painted and carved wooden masks, basketry and silver jewellery work. Elsewhere in the region the Navajos were masters of the sacred sand painting, which they carried out in five symbolic colours of black (north, also denoting male), white (east), red (sunshine), yellow (west) and blue (south and female). Paintings were destroyed after a particular ceremony was over, and designs followed strict rules handed down from one generation to the next.

In the Pre-Columbian period many Plains Indian tribes lived in permanent earth-lodge villages, where their artistic output included pottery and skin paintings. With the arrival of the Spanish settlers they acquired horses for the first time and gradually took to a nomadic life following the buffalo; as a result some of their earlier art forms were abandoned – pottery, for example, giving way to portable rawhide vessels.

The Eastern Woodlands area is rich and stretches from the Great Lakes to the valley of the Mississippi. Among the most interesting archaeological remains in North America are the stone and pottery sculptures of the early inhabitants of the Mississippi Valley, known as the 'Mound-Builders' after the gigantic mounds and earthworks they constructed, some of them 300–

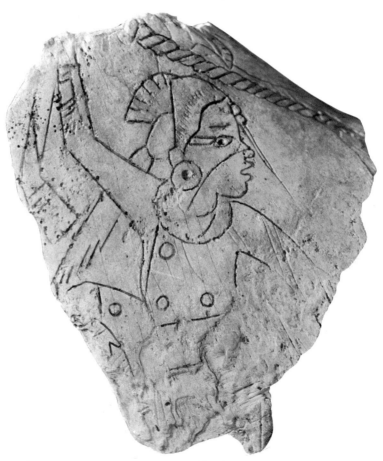

13 *Indian art of the Eastern Woodlands : Incised shell fragment from the Spiro Mound. Museum of the American Indian, New York.*

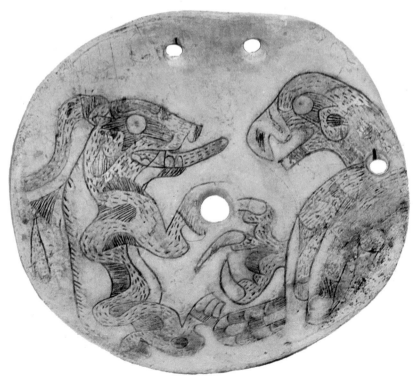

14 *Indian art of the Eastern Woodlands : Shell gorget incised with animal
forms. Museum of the American Indian, New York.*

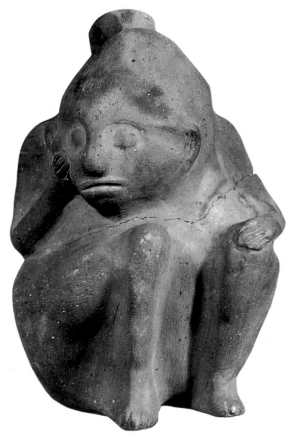

15 *Mississippi Valley art : Clay vessel with figure. Museum of the American Indian, New York.*

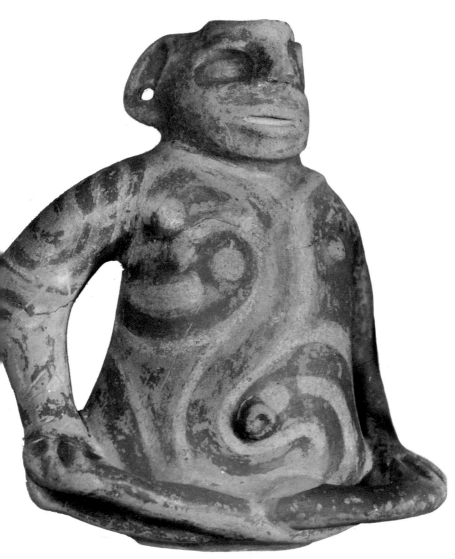

16 *Mississippi Valley art : Clay jar with figure. Museum of the American Indian, New York.*

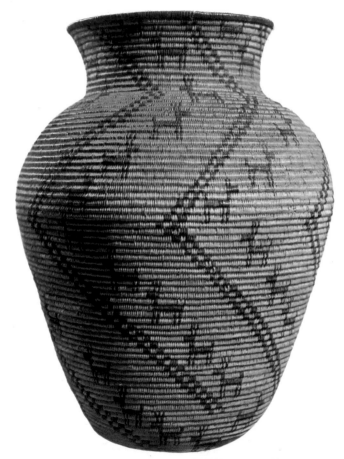

17 *South-West Indian art, Apache culture : Urn-shaped basket with antelope design. United States Department of the Interior Museum, Washington, DC.*

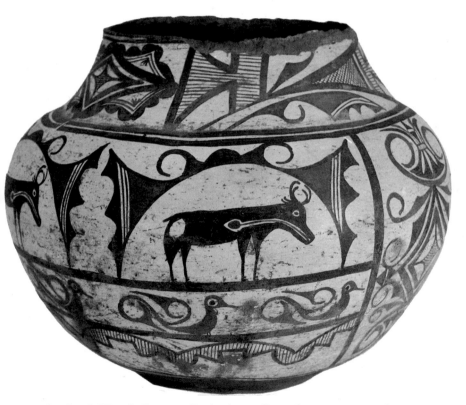

18 *South-West Indian art, Zuni culture : Painted terracotta vase. British Museum, London.*

13 Indian art of the Eastern Woodlands: *Incised shell fragment* from the Spiro Mound, Oklahoma. Museum of the American Indian, New York.
This and other finely detailed carvings from the Spiro Mound illustrate ancient ritual customs.

14 Indian art of the Eastern Woodlands: *Shell gorget incised with animal forms*. From the museum above.
The free and vigorous outlines show a remarkable artistic maturity.

15 Mississippi Valley art (Eastern Woodlands): *Clay vessel with figure*. From the museum above.
This vessel, found in a burial-mound in St Louis, has an extraordinary emotive power.

16 Mississippi Valley art (Eastern Woodlands): *Clay jar with figure*. From the museum above.
The figure is extremely well modelled and is decorated with a red pigment motif on a cream background.

17 South-West Indian art, Apache culture: *Urn-shaped basket with antelope design*. United States Department of the Interior Museum, Washington, DC.
These people produced many beautifully decorated basketwork objects in a variety of shapes and weaves.

18 South-West Indian art, Zuni culture: *Painted terracotta vase*. British Museum, London.
South-West painted ceramics are often characterized by their stylized geometric patterns.

19–20 South-West Indian art, Zuni culture: *Kachina doll*, from New Mexico. *Nahatesho mask*. Brooklyn Museum, New York.
Although crudely made these ritual objects make an immediate and forceful impression on the viewer.

19 *South-West Indian art, Zuni culture :*
Kachina doll from New Mexico. Brooklyn
Museum, New York.

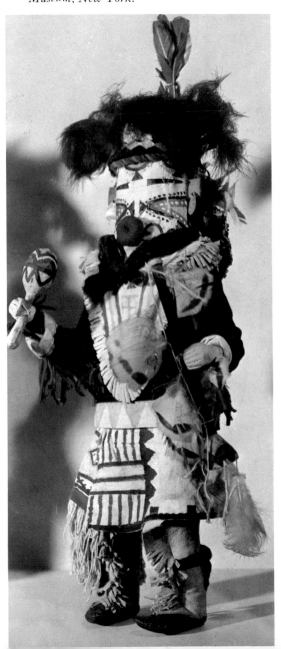

20 *South-West Indian art, Zuni culture : Nahatesho mask. Brooklyn Museum, New York.*

400 metres wide and over ten metres high. The sculptures are usually in the form of small crouching figures, drinking cups or pipes carved in bird or animal shapes. Wooden ritual masks were widely used in the Eastern regions, especially by the Iroquois, and portray grotesque demons and spirits.

MEXICAN ART

The most ancient Mexican civilizations probably originated in groups of nomadic hunters of Asian origin, who occupied the region as long as 20,000 years ago. It is impossible to say with any precision when these nomadic peoples evolved from a primitive life of hunting and food gathering and began to develop settled farming communities. But it is generally accepted that there was a long formative period, lasting until roughly 2000 BC and known today as the Palaeo-Indian phase. It has produced no evidence of important artistic activity, though it is reasonable to assume that by its end the inhabitants of the region had reached a level compatible with the founding of an organized civilization. Domestic farming was by then under way; between that time and about AD 100 megalithic stone sculptures were created and pottery objects were made and decorated with monochrome designs; there was jade carving, and an early religious architecture was formulated. The works of this period, the Pre-Classical, reveal a growing maturity and are important not only in themselves but for paving the way to the elaborate and sophisticated art of Classical Mexico.

Pre-Classical culture is divided into three phases – Lower, Middle and Upper. It developed mainly in the central plateau of Mexico and lasted until the end of the first century AD. El Arborillo, Zacatenco and Tlatilco are the most ancient centres to have yielded important finds. Many other centres developed in the course of time, some of them not in the central plateau but in areas such as Chupiquaro (State of Guanajuato, on the Pacific Coast) and Santa Cruz (State of Morelos). The people of the Lower Pre-Classical period lived in tribes in autonomous villages and were hunters, fishermen and farmers; maize was their main crop. They had wattle-and-daub houses and wore skins and garments made of vegetable materials. They were highly skilled at moulding clay to make terracotta pottery. The solemnity of their funeral rites shows their belief in an after-life, and also in various forms of magic. Gradually there evolved more sophisticated systems of religious and political organization, as well as important technical advances. New materials were used – jade, quartz, kaolin and others – although this sometimes brought about a simultaneous decline in artistic quality.

The most ancient known culture is that of Zacatenco: examples of its art that have been found include burial furniture consisting of clay vases in various shapes with decorations ranging from simple incised geometric motifs to more complex representations of animals carried out in one or several colours. At Tlatilco, which is a few miles from Mexico City, flints, obsidians and fine vases in animal and human shapes

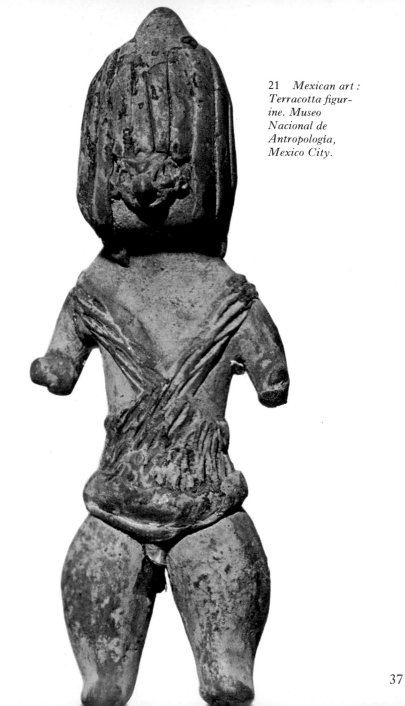

21 Mexican art :
Terracotta figur-
ine. Museo
Nacional de
Antropología,
Mexico City.

37

22 *Mexican art, Tlatilco culture : Anthropomorphic vase representing a duck-man. 1000–800 BC. Private Collection, Mexico.*

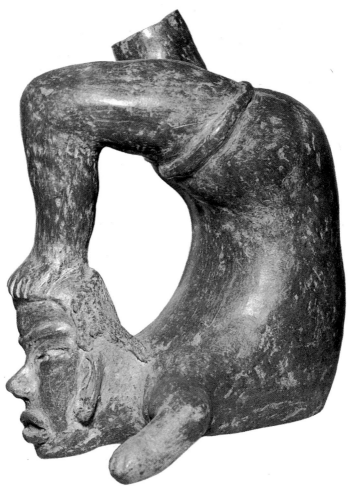

23 *Mexican art, Tlatilco culture : Vase in the shape of an acrobat.*
1000–800 BC. Private Collection, Mexico.

21 Mexican art: *Terracotta figurine*. Museo Nacional de Antropología, Mexico City.
Although the body of this figure is modelled with some concern for anatomical accuracy, the head is a strangely ambiguous shape, part animal and part human.

22 Mexican art, Tlatilco culture: *Anthropomorphic vase representing a duck-man*. 1000–800 BC. Private Collection, Mexico.
The image of the duck-man with his red head on a body of black polished terracotta has a great freshness.

23 Mexican art, Tlatilco culture: *Vase in the shape of an acrobat*. 1000–800 BC. Private Collection, Mexico.
Several objects from Tlatilco combine caprice and grotesqueness with such complexity that it is impossible to trace their original significance.

24 Mexican art, Tlatilco culture: *Globular terracotta vessel*. 1000–800 BC. Private Collection, Mexico.
Vessels were found at Tlatilco in abundance, ranging from small spherical vases and zoomorphic jugs to long-necked vessels with globular bases.

25–6 Mexican art, Tlatilco culture: *Terracotta sculptures in yellow ochre of a seated man* (left) and an *amphora in the shape of a seated woman* (right). 1000–800 BC. Private Collection, Mexico.
Tlatilco figurines share several common features of size, colouring and proportion.

27 Mexican art, Ticoman culture: *The Pyramid of Cuicuilco*.
A rough flight of steps set into one face and a high ramp on the opposite side lead up to the summit of this pyramid.

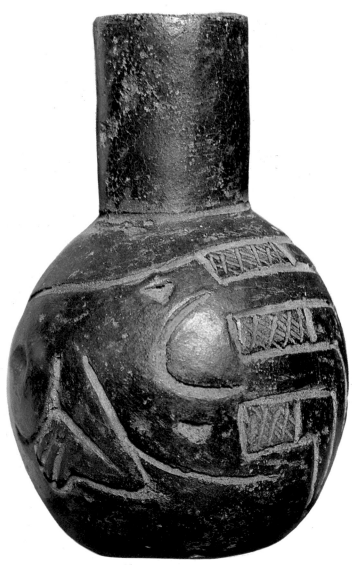

24 *Mexican art, Tlatilco culture : Globular terracotta vessel.*
1000–800 BC. Private Collection, Mexico.

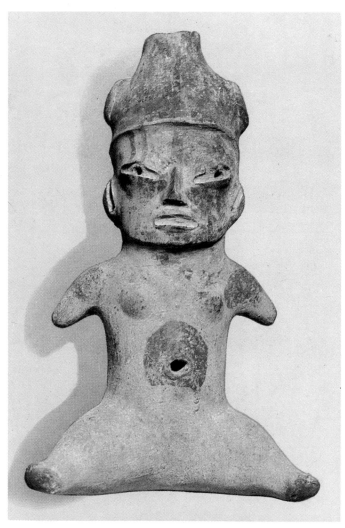

25 *Mexican art, Tlatilco culture : Terracotta figure of a seated man. 1000–800 BC. Private Collection, Mexico.*

26 *Mexican art, Tlatilco culture : Amphora in the form*
of a seated woman. 1000–800 BC. Private Collection,
Mexico.

27 *Mexican art,
Ticoman culture :
The Pyramid of
Cuicuilco.*

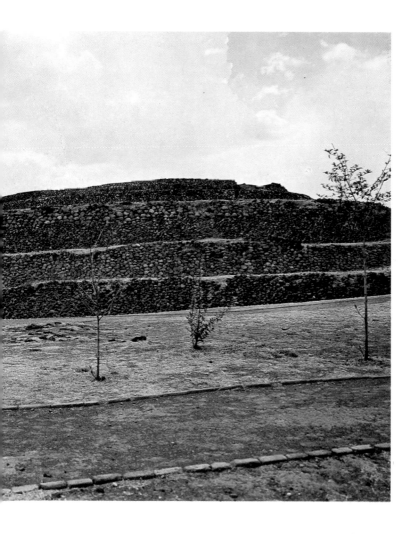

have been found, together with exquisitely made terra-
cotta figurines that clearly belong to Zacatenco cul-
ture, despite certain minor local characteristics. They
are normally about three to four inches high and
almost exclusively feature a type of young woman,
small-breasted and with a slim torso and short arms;
the hips and legs are accentuated and she is generally
naked except for an elaborate headdress. These figur-
ines appear to have represented not so much an object
of religious symbolism as an ideal of feminine beauty.
Tlatilco also revealed a number of terracotta and stone
objects that definitely belong to Olmec culture; these
were surprising finds since the latter culture was origi-
nally thought to be much later than Zacatenco.

Zacatenco culture disappeared from the central pla-
teau of Mexico without leaving any trace of its decline.
However, at the religious centre of Zacatenco itself
new stylistic variations appeared that mark the begin-
ning of a new period – the Upper Pre-Classical phase.
The centre of this culture was Ticoman in the Valley
of Mexico; stylistically its products were inferior to
preceding periods. The figures are less imaginative
and vases were made in rougher and more simplified
forms. But new types of decoration were coming into
use including the figure of the fire-god, who was part
of the developing religious lore and was to recur fre-
quently in the art of successive periods. He was repre-
sented as an old man sitting cross-legged and bearing
the weight of a brazier on his head. Many objects found
in the vast Chupiquaro burial-ground belong to the
same period, including elegant and delicately made

pottery often decorated in several colours, and well-modelled anthropomorphic figurines, the main types being either large and hollow or small and solid.

The first pyramids were built at Cuicuilco and at Tlapacoya, in the Valley of Mexico. They stand as clear proof that these characteristic religious monuments, later to appear throughout central America, date back to the Pre-Classical period in Mexico. Contemporary research has added little to the small amount that is known about the final four or five centuries of the Pre-Classical period, from the decline of Ticoman culture to the beginning of Teotihuacan culture in the same area. We know of no cultures flourishing at that time, nor do we have any evidence of the final phase of evolution that must have linked the Pre-Classical period to the Classical. The most widely accepted theory is that the controversial Olmec culture belongs to this transitional phase, although its dating still poses one of the most enigmatic problems in the history of Pre-Columbian art. The Olmecs are difficult to define geographically or within precise chronological limits; and yet their art, by its maturity, its style and expressive intensity ranks with the finest works ever produced in the region.

During the Spanish conquest it was traditionally claimed in Mexico that the Olmecs were the most ancient of all the indigenous peoples to have had a highly developed civilization. Their name came from the earliest chronicles, which told of remote inhabitants living on the Gulf Coast – the 'land of rubber', from which their name is derived, since *olli* means

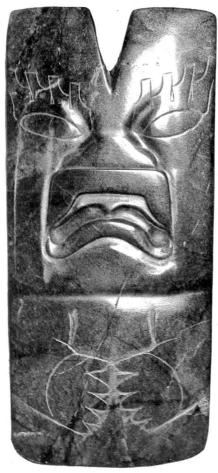

28 *Mexican art, Olmec culture : Ceremonial jade axe, known as the 'colossal axe'. 800 BC–AD 100. Museo Nacional de Antropología, Mexico City.*

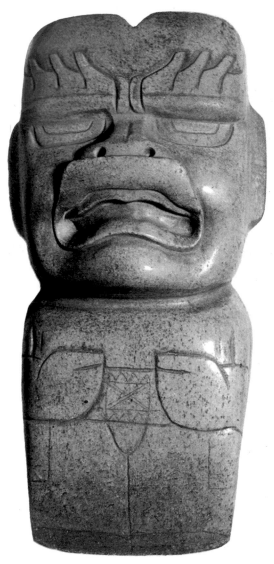

29 *Mexican art, Olmec culture : Jade head. British Museum, London.*

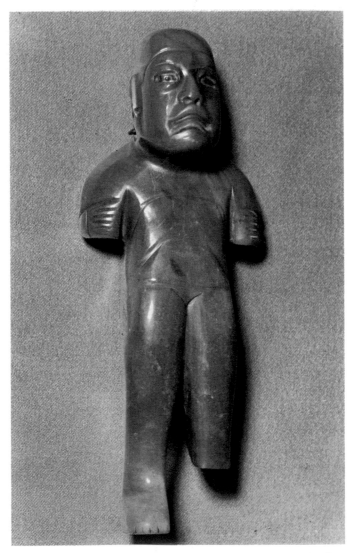

30 *Mexican art, Olmec culture : Standing jade figure. 800 BC–*
AD 100. Museum für Völkerkunde, Vienna.

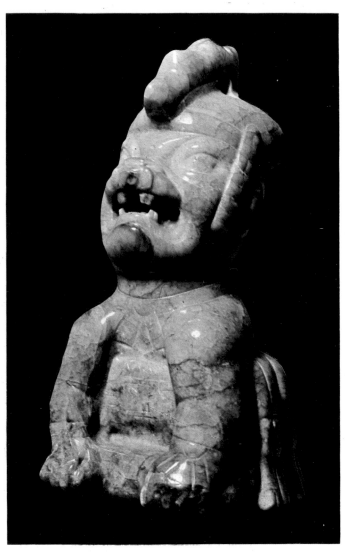

31 *Mexican art, Olmec culture : Jade dragon. American Museum of Natural History, New York.*

28 Mexican art, Olmec culture: *Ceremonial jade axe known as the 'colossal axe'.* 800 BC–AD 100. Museo Nacional de Antropología, Mexico City. ·
This large ceremonial axe has several minor features – eyelids, eyes, a broad flat nose and hands joined across the chest. The mouth is much more powerfully carved and the jaws are those of a jaguar rather than a human being.

29 Mexican art, Olmec culture: *Jade head.* British Museum, London.
The Olmecs were one of the first peoples of Meso-America to use jadeite, which they prized greatly for its translucency and because it was comparatively rare.

30 Mexican art, Olmec culture: *Standing jade figure.* 800 BC–AD 100. Museum für Völkerkunde, Vienna.
Olmec jade carvings normally have a smooth finish, the lesser features being lightly incised in order not to reduce the power of the dominant image – usually the mouth.

31 Mexican art, Olmec culture: *Jade dragon.* American Museum of Natural History, New York.
The image here of the dragon or some such fantastic creature is ferocious and probably had a deterrent function.

32 Mexican art, Olmec culture: *Seated female nude.* Private Collection, Mexico.
This is a typical Olmec sculpture: its finish is smooth and the head has the distinctive Olmec shape and tilt; the lips, too, are characteristic.

33 Mexican art, Olmec culture: *Steatite acrobat.* Museo Nacional de Antropología, Mexico City.
This figure recalls that of the Tlatilco acrobat (see illustration 23) but is modelled with greater vigour and assurance.

32 *Mexican art, Olmec culture : Seated female nude. Private Collection, Mexico.*

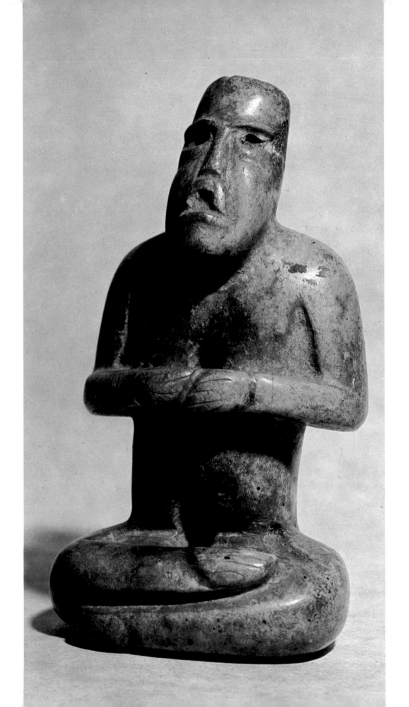

53

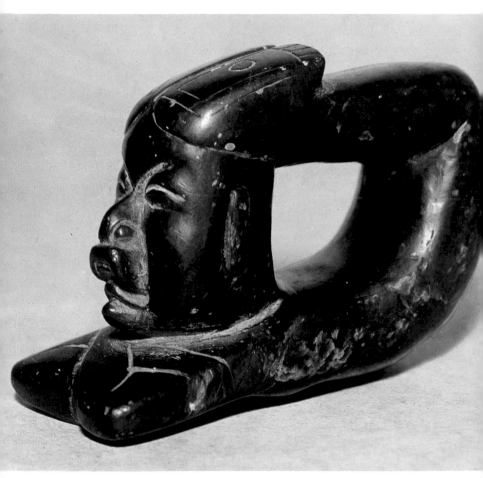

33　*Mexican art, Olmec culture : Steatite acrobat. Museo Nacional de Antropología, Mexico City.*

rubber. It is impossible to verify this account of their origins, or indeed to discover anything certain about their civilization. This undoubtedly goes back to the Pre-Classical period, but while it is generally believed that it reached its zenith in the sixth or fifth century BC, other finds seem to contradict this view and indicate that it came at an earlier period. For example, the Olmec objects found alongside the remains of Zacatenco culture at Tlatilco (mentioned earlier) are certainly older than the sixth century BC. They are, furthermore, so stylistically mature and of such aesthetic refinement that it seems they must have been produced at a peak period in Olmec culture.

The centres of this mysterious culture are equally hard to define, since traces of it have been found almost everywhere in Mexico. It seems likely that at some moment in their history the Olmecs controlled the whole of Mexico; to the south their influence can be traced almost as far as Peru. The best-known centres, those that have yielded the most interesting finds, are in the States of Vera Cruz and Tabasco, at Tres Zapotes, San Lorenzo and La Venta. From there came the most astonishing examples of Olmec art, mainly portrait statuary in a variety of shapes and sizes. There is no definite evidence of an Olmec religious cult, but the recurrence of certain motifs and the clearly symbolic significance of some figures, indicate the existence of certain magic rites and beliefs. One image in particular, that of the jaguar, appears constantly in Olmec art either as an animal figure or as a highly stylized face imposed on a human body.

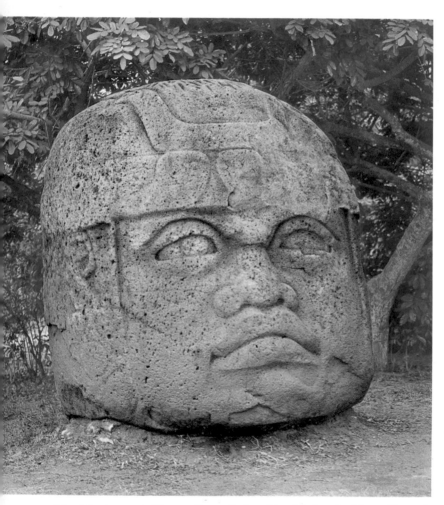

34 *Mexican art, Olmec culture : Colossal head in basalt. Museo-Parco de La Venta, State of Tabasco.*

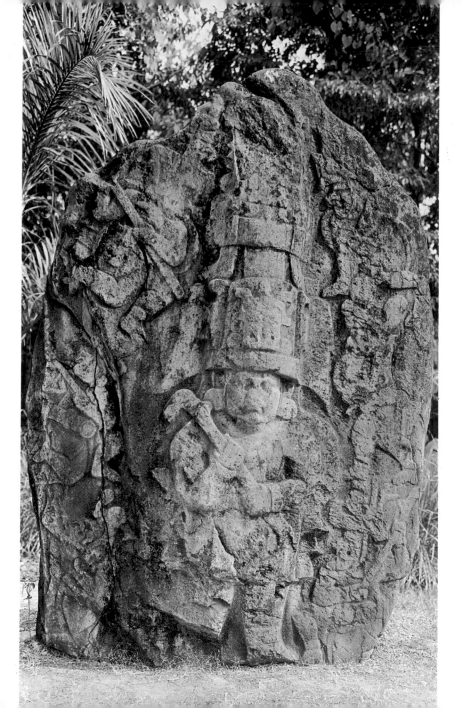

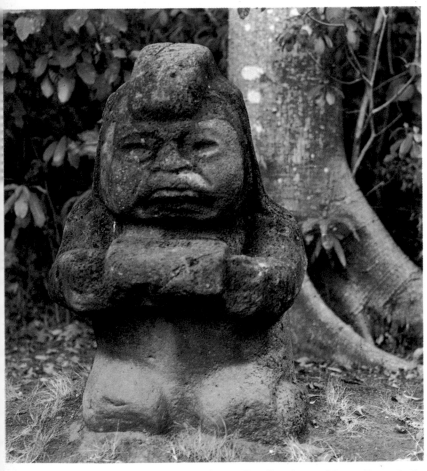

36 *Mexican art, Olmec culture : Kneeling figure. Museo-Parco de La Venta, State of Tabasco.*

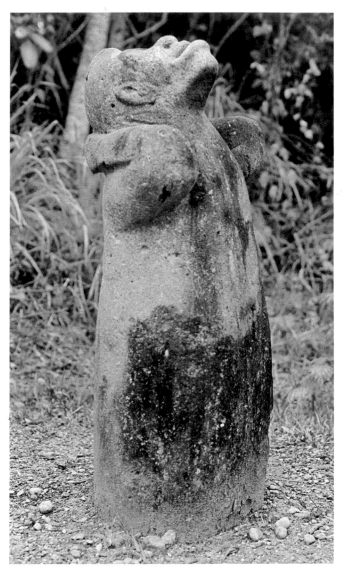

37　*Mexican art, Olmec culture : Ape looking up to heaven.*
800 BC–AD 100. Museo-Parco de La Venta, State of
Tabasco.

34 Mexican art, Olmec culture: *Colossal head in basalt.*
Museo-Parco de La Venta, State of Tabasco.
More than six feet high and eighteen feet in circumference,
this head is one of a number of monumental Olmec sculp-
tures, sometimes referred to as the 'baby faces', the fea-
tures being far less exaggerated than in the smaller works.

35 Mexican art, Olmec culture: *Stele of 'the King'.*
Museo-Parco de La Venta, State of Tabasco.
The figure of the warrior-king occupies the whole central
panel of this stele; he is shown holding a weapon or a sign
of office and wearing a tall headdress.

36–7 Mexican art, Olmec culture: *Kneeling figure* (left)
and *Ape looking up to heaven* (right). 800 BC–AD 100.
Museo-Parco de La Venta, State of Tabasco.
The open-air setting of the La Venta Museum-Park helps
to show something of the extraordinary power that these
works must have exerted in their own time.

38 Mexican art, Olmec culture: *Stone sarcophagus.* 800
BC–AD 100. Museo-Parco de La Venta, State of Tabasco.
In the central niche is a seated figure carved in the round,
probably representing the dead man, while the rest of the
massive sarcophagus is decorated with bas-reliefs.

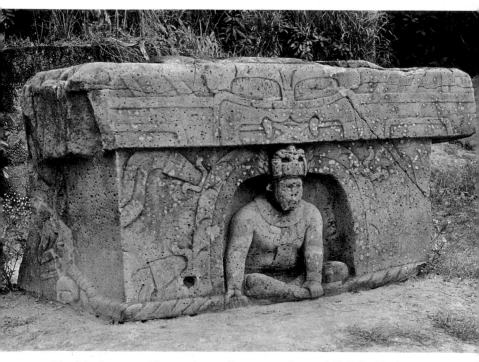

38 *Mexican art, Olmec culture : Stone sarcophagus. 800 BC–AD 100.*
Museo-Parco de La Venta, State of Tabasco.

The Olmecs, usually working in stone, devised their own monumental sculpture: there is a most impressive series of colossal basalt heads, many of them eight feet high and weighing up to fifteen tons, found in the States of Tabasco and Vera Cruz; another great artistic achievement are the great stone altars decorated with sculpture and bas-reliefs that were discovered in a jungle area at the southern end of the Gulf, some fifty miles from any possible source of stone. Olmecs were evidently prepared, in pursuit of some unknown religious or philosophical goal, to find the means to transport enormous blocks of stone over vast distances; the works of art they then created reflect this extraordinary inner drive. Many smaller sculptures have also been found, including figures of bearded men, dwarfs, hunchbacks, infants and jaguars, pectorals with human or feline faces, and mosaic floors featuring a stylized version of the jaguar.

The disappearance of Olmec culture is as mysterious as its origins; a small statue from Los Tuxtlas and a stele fragment from Tres Zapotes found recently are inscribed respectively AD 162 and 21, and were probably made during the final phase.

The West Coast

Little is known of the various interesting cultures that flourished from an early date in the vast area of Western Mexico. Archaeological evidence is so scarce that it is not even possible to ascertain whether they were Pre-Classical cultures. However, the objects that have been found are definitely Pre-Classical in style and

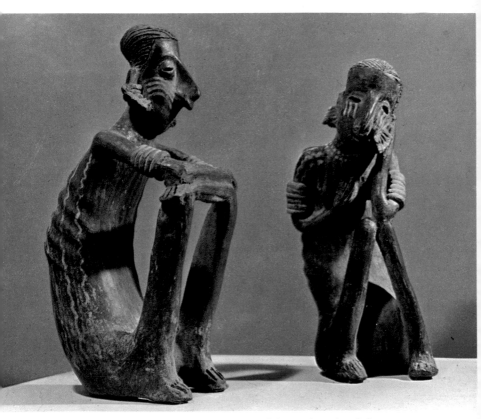

39　*Mexican art, Nayarit culture : Two seated figures in painted clay.*
Museum of Primitive Art, New York.

39 Mexican art, Nayarit culture: *Two seated figures in painted clay*. Museum of Primitive Art, New York.
The figures of Nayarit art are crudely modelled in an archaic style; the clay is badly baked, or was possibly just sun-dried.

40 Mexican art, Nayarit culture: *Seated woman*. Private Collection, Mexico.
The shape of this figure, the token breasts and arms receding in the background and the powerful legs and elongated head in the foreground suggest not only an image of fertility but also an attempt to deal with problems of perspective.

41 Mexican art, Nayarit culture: *Seated man*. Private Collection, Milan.
This figure has a certain harmony of outline and its colouring is more delicate than is usually found in Nayarit polychrome work. The figure holds a rattle in its right hand.

42 Mexican art, Colima culture: *Barking dog*. Museo Nacional de Antropología, Mexico City.
This type of Mexican dog, not unlike the modern breed of Chihuahua, recurs frequently in Colima ceramic art.

43 Mexican art, Guerrero culture: *Carved stone mask*. American Museum of Natural History, New York.
This minimally carved, eyeless head typifies the preference in early Mexican sculpture for plain, massive images.

44 Mexican art, Guerrero culture: *Small jadeite figures*. Museo Nacional de Antropología, Mexico City.
Three Guerrero carvings showing three kinds of Central American jadeite – the hardest and most highly valued variety of jade.

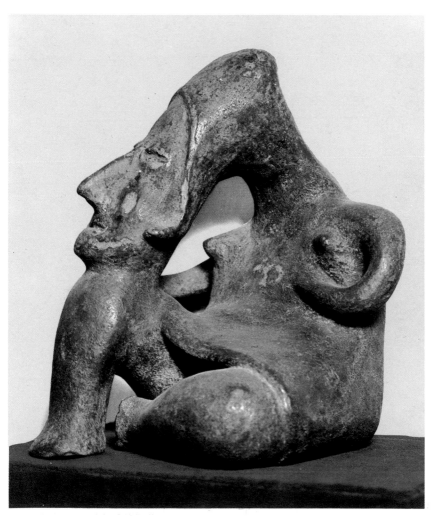

40　*Mexican art, Nayarit culture : Seated woman. Private Collection, Mexico.*

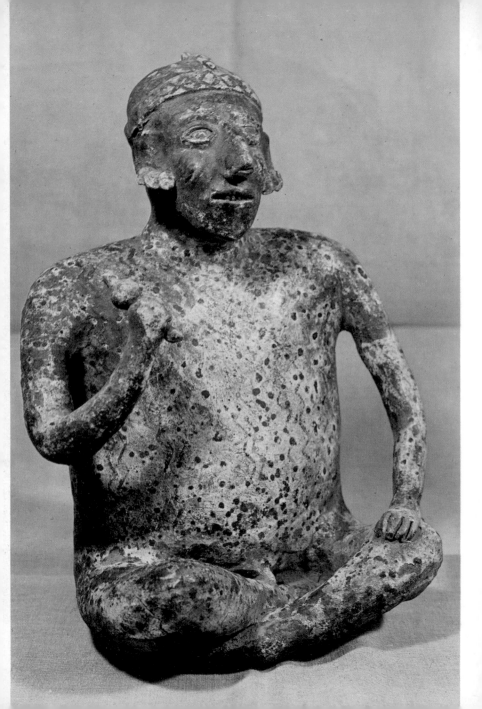

41 *Mexican art, Nayarit culture : Seated man. Private Collection, Milan.*

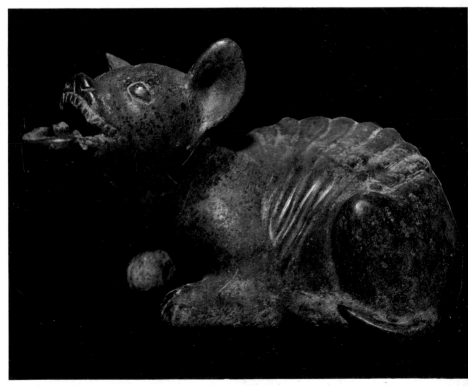

42 *Mexican art, Colima culture : Barking dog. Museo Nacional de Antropología, Mexico City.*

43 *Mexican art, Guerrero culture : Carved stone mask.*
American Museum of Natural History, New York.

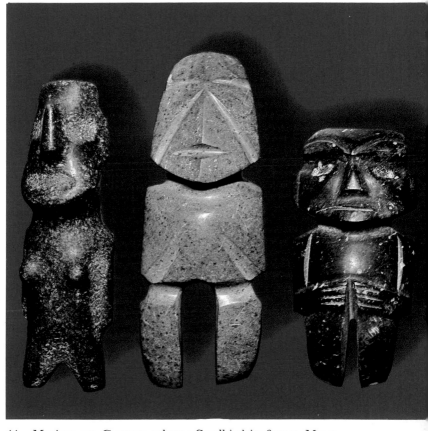

44 *Mexican art, Guerrero culture : Small jadeite figures. Museo Nacional de Antropología, Mexico City.*

spirit even if they cannot be dated with any precision. The cultures originating in the regions of Nayarit, Colima, Jalisco and Michoacan have their own characteristic styles, and also share certain common features, especially in pottery. The standard of modelling and baking is always extremely high, and the technical competence of these early potters enabled them to make quite large and ambitious clay statues : these portray scenes from daily life with great imagination and spontaneity. Stone carving was limited to a few areas such as Mezcala in the State of Guerrero, where small statues and tools such as axes and hammers were produced. Such finds as have been made are from tombs buried deep in the ground, and consist of objects placed as offerings round the body of the dead man. Typical Nayarit works are their terracottas of human figures, usually naked, the anatomical details exaggerated and at times grotesquely out of proportion. The atmosphere projected by these figures is often comic and suggests a comparatively uncomplicated world unencumbered by religious obligations.

In contrast, the art of the neighbouring state of Jalisco shows greater maturity and sense of purpose : the modelling of the terracottas is firmer and they have a vigour that is often lacking in the more carefree Nayarit pieces.

Of the more important West Coast cultures the State of Colima produced terracottas of the highest artistic quality; so high in fact that it is difficult to detect any Pre-Classical elements in them. They commemorate characters and events of daily life with charm and

vigour, and are outstanding for their highly realistic details – the careless pose of a sleeping warrior or the sharp agonies of a woman in childbirth. Other works in the same style include animal figures, especially the popular *techichi* dog, and a number of plant-shaped vases made in a refined style.

A variety of cultures developed in the course of time in the State of Guerrero, where the influence of neighbouring styles has in many cases modified the characteristic features of the local art; however there is still too little evidence to trace the history of this area with any accuracy. Mostly from the Pacific coastland area of Guerrero came a wide variety of characteristic vases and terracotta figurines, and also many Olmec jade objects and small stone masks and sculptures that clearly belong to the Pre-Classical period. Some masks and other stone carvings may belong to the early Classical period; these also show elements of Teotihuacan style. In the Mezcala River area a highly expressive local style grew up, as may be seen from the wide variety of sculptures found there – human and animal figures, stylized masks and other objects carved from different types of coloured, usually very hard, stone, which is either left smooth and polished or decorated with deep incisions. Many Olmec-influenced objects have been found in the same area but they also have pronounced archaic features, which probably indicates that Olmec culture evolved at an early period in the State of Guerrero, before reaching its zenith along the Gulf Coast.

Teotihuacan Civilization

The first great cultures of the Classical period are distinguished by their organization of society into classes led by a ruling caste of priests, by technical progress in agriculture and crafts and by a more highly developed system of religious beliefs and rites that formed the basis of their art and daily life. The imposing remains of the great religious centres that were built in this period still stand today as evidence of the achievements of Teotihuacan civilization. The most interesting is the city of Teotihuacan itself, spread over an area of about ten square miles in the central plateau and some thirty miles from Mexico City.

Originally it must have covered an even wider area, as the religious centre was surrounded by outlying areas of clay-brick buildings that have completely disappeared. There is no evidence of the date this city was founded, nor of the people who built it, although many theories exist. We know only that the zenith of this civilization must have been roughly between the third and fourth centuries AD and that the city was abandoned by its inhabitants between 700 and 800 – again for unknown reasons, traces of fire and destruction being the only visible indications of its downfall.

The central nucleus of the city consisted of temples and buildings dedicated to the practice of religion and the dwellings of the priestly caste. (The sacred character of Teotihuacan is clear from its name, which means 'birthplace of the gods'.) Among the most outstanding buildings are two enormous pyramids, called the Pyramids of the Sun and of the Moon. Their

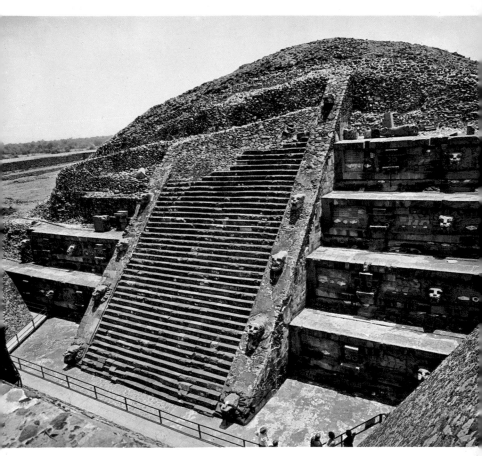

45 *Mexican art, Teotihuacan culture : Temple of Quetzalcoatl.*

45 Mexican art, Teotihuacan culture: *Temple of Quetzal-coatl.*
The Temple of Quetzalcoatl is not particularly large but its massive steps contain numerous fine carvings.

46 Mexican art, Teotihuacan culture: *Fragment of a wall painting.* Museo Arqueológico, Teotihuacan.
Like the Mayas, though less successfully, the artists of Teotihuacan gave perspective and depth to their work.

47 Mexican art, Teotihuacan culture: *Greenstone carving representing Quetzalcoatl.* Museum of the American Indian, New York.
Quetzalcoatl is the god of the Morning Star and of the air and is one of the most important mythological characters.

48 Mexican art, Teotihuacan culture: *Funerary mask partly covered with mosaic.* AD 300–650. Museo Nacional de Antropología, Mexico City.
The artist has not attempted a true portrait of the dead man's face, but instead has made a simplified geometric image; a pendant is attached to the lower edge of the mask.

49 Mexican art, Teotihuacan culture: *Effigy vase of Tlaloc in green jade.* AD 300–650. Museo Nacional de Antropología, Mexico City.
Sculptures of Tlaloc, the rain-god, have certain constant characteristics: the eyes are surrounded by concentric circles, and he has wide feline jaws from which toads are sometimes seen to emerge.

50 Mexican art, Teotihuacan culture: *Vase with fresco decoration.* AD 300–650. Museo Nacional de Antropología, Mexico City.
Typical of Teotihuacan ceramic art, this vessel is gently shaped towards the top and mounted on a tripod.

46 *Mexican art, Teotihuacan culture : Fragment of a wall painting.*
Museo Arqueológico, Teotihuacan.

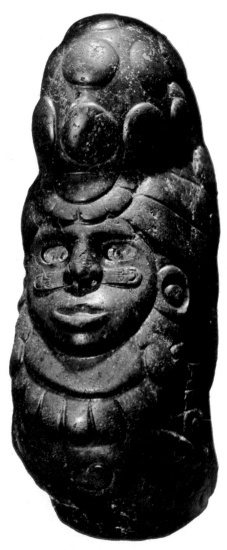

47 *Mexican art, Teotihuacan culture : Greenstone carving representing*
Quetzalcoatl. Museum of the American Indian, New York.

48　*Mexican art, Teotihuacan culture : Funerary mask partly covered with mosaic. AD 300–650. Museo Nacional de Antropología, Mexico City.*

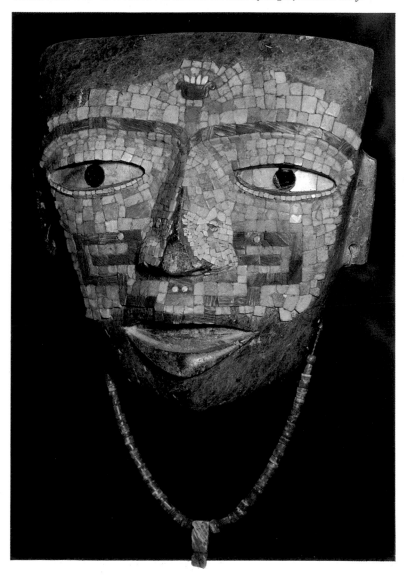

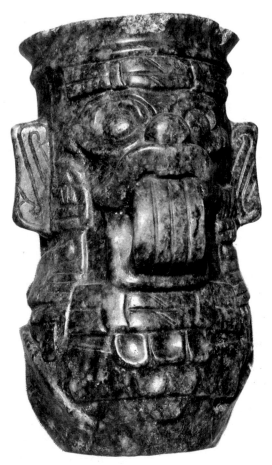

49 *Mexican art, Teotihuacan culture : Effigy vase of Tlaloc in green jade.*
AD 300–650. Museo Nacional de Antropología, Mexico City.

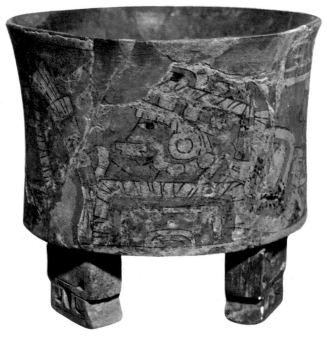

50 *Mexican art, Teotihuacan culture : Vase with fresco decoration.*
AD 300–650. Museo Nacional de Antropología, Mexico City.

steeply sloping terraces are crowned with the flat platform typical of American pyramids. The exterior is made of huge clay bricks faced with stones and covered with a smooth coat of lime plaster; there are steps at the centre of the base on one side and then an immense staircase leads from a landing to the summit. Wall paintings were a favoured form of decoration at Teotihuacan, for example in the so-called Temple of Agriculture, which has wonderful frescoes.

Teotihuacan culture is subdivided into four phases. The first three cover the artistic development of Teotihuacan itself, and the final phase describes the continuation of this culture in other areas after the city was abandoned. The earliest artistic products of the first phase were terracotta objects for daily use bearing incised or painted geometric decorations; some figurines with Pre-Classical characteristics have also been found. During the second phase this art went through a period of rapid evolution and some fine pieces were produced, including small figures and vases, usually with tripod legs and often beautifully decorated with enamels or frescoes. Some of the finest examples are in *thin orange* ware, so called because of its colour and almost transparent thinness. The magnificent stone sculpture of Teotihuacan was mostly designed to decorate the temples and pyramids. It is vigorously carved and at times quite strongly stylized. The feathered serpents and the figures of Tlaloc the rain god in the Temple of Quetzalcoatl, and the vast monolithic water-goddess found near the Pyramid of the Moon all belong to this second phase. The fire-god,

previously represented in Ticoman art, is one of the most characteristic figures of Teotihuacan culture, and is usually given great expressive intensity. This is also true of the magnificent and extremely rare masks probably inspired by Olmec art that evolved over a period of time to become some of the most beautiful examples of ancient Mexican art. The third phase shows the full development of Classical sculpture, when art reached a maturity and refinement inspired by deep religious feeling. Every element seems to have a symbolic meaning explaining man's relationship to the gods. Architecture, painting and sculpture all show a more mature handling of earlier themes; this same maturity can be seen also in ceramic art, in which a new technique was used to reproduce whole series of the finest figurines by means of plaster casts. Then Teotihuacan was suddenly abandoned. Although its culture survived elsewhere for a time it was clearly decadent and soon disappeared for ever.

Monte Albán Culture
Monte Albán was a religious centre as important in the State of Oaxaca as was Teotihuacan in the central plateau of Mexico. Situated on an excellent strategic and commercial site at the meeting of three valleys, at a height of 6,000 feet, this city was famous for its complex and imposing temples, palaces and other buildings. Nothing is known of the origins of the city's founders but in due time it became a religious centre for the Zapotecs, whose art style dominated the Classical culture in the region from AD 400–500 until 1000.

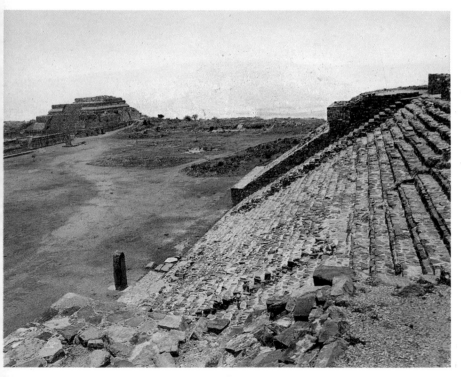

51 *Mexican art, Zapotec culture : Part of the staircase of a temple at Monte Albán, near Oaxaca.*

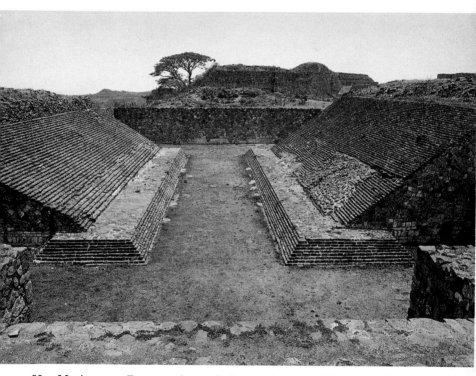

52 *Mexican art, Zapotec culture : Ball court at Monte Albán, near Oaxaca.*

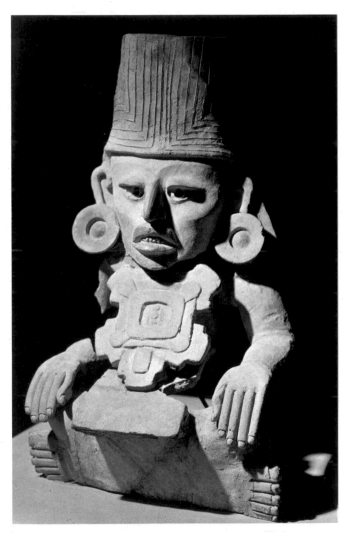

53 *Mexican art, Zapotec culture : Funerary urn in the form of a goddess. Museo Nacional de Antropología, Mexico City.*

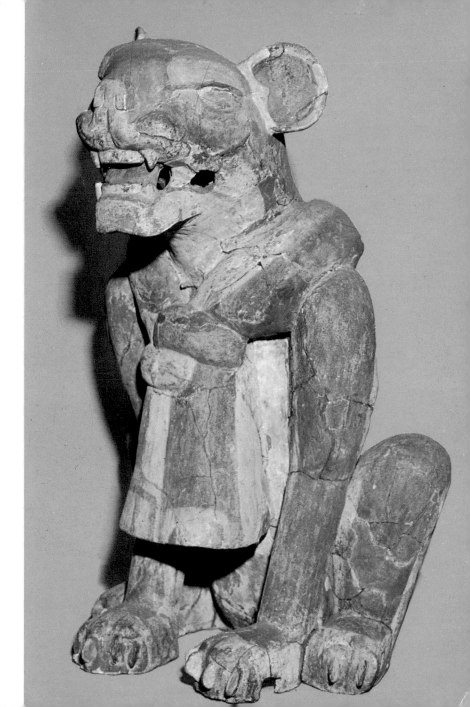

51 Mexican art, Zapotec culture : *Part of the staircase of a temple at Monte Albán, near Oaxaca.*
This and other temples erected on truncated pyramids surround the open plaza at Monte Albán.

52 Mexican art, Zapotec culture: *Ball court at Monte Albán, near Oaxaca.*
The court forms part of the remains of a temple enclosure at Monte Albán; the whole complex was built on the mountain top – which was artificially flattened – and measures 2,300 feet long and 820 feet wide.

53 Mexican art, Zapotec culture: *Funerary urn in the form of a goddess.* Museo Nacional de Antropología, Mexico City.
The figure of a goddess recurs frequently in Zapotec terracotta urns; the features are constant and include a tapering nose, large eyes and half-open lips showing sharply filed teeth.

54 Mexican art, Zapotec culture: *Funerary urn in the form of an animal.* Museo Nacional de Antropología, Mexico City.
Funerary urns evolved from early vases decorated with grotesque masks to urns made in human and animal forms.

55 Mexican art, Zapotec culture: *Ceremonial pectoral.* Museo Nacional de Antropología, Mexico City.
This jade piece represents the bat-god, its eyes and teeth are made of shell; the holes pierced on either side were threaded with a cord and the pectoral worn round the neck on ritual occasions.

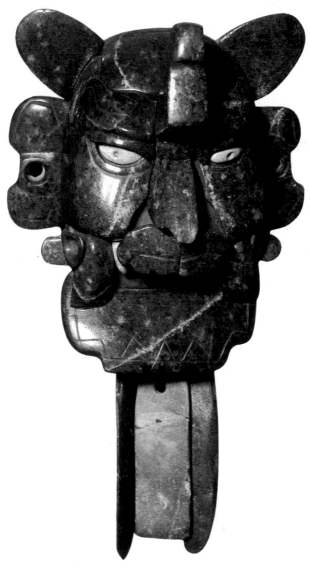

55 Mexican art, Zapotec culture : Ceremonial pectoral.
Museo Nacional de Antropología, Mexico City.

Numerous excavations at Monte Albán have revealed important finds permitting detailed research into the successive artistic phases of Zapotec culture. The foundation of the city dates back to the Pre-Classical period and its first great buildings belong to the sixth century BC. Pottery and terracotta figurines, vigorously modelled, also have Pre-Classical characteristics, as well as certain Olmec elements. This is particularly true of a wonderful series of stone reliefs showing human figures, who appear to be dancing and are carved with an evident sense of the grotesque. These stone slabs also bear hieroglyphic inscriptions and dates conveyed in a system of dots and lines that have so far been, unfortunately, indecipherable. Later works, ceramics, stone engravings and stelae belonging to what is known as the second period show a marked evolution in style. There were, too, terracottas of an astonishing beauty and majesty. It is now thought that these were probably the creations of a superior caste of artists, who had attained a particularly high level of civilization. The facial characteristics of the figurines are similar to Olmec portrait statuary; they are richly clothed and often seem to be making some gesture of repulsion: their big tapering hands are raised in front of their chests, the palms turned outwards. Many funerary urns from this period are far more than mere containers: they are transformed by their richly carved decorations, sometimes in the form of a mask, into burial sculptures of a high order. A stupendous pectoral mask of green jade and shell now in the Museo Nacional de Antropología in

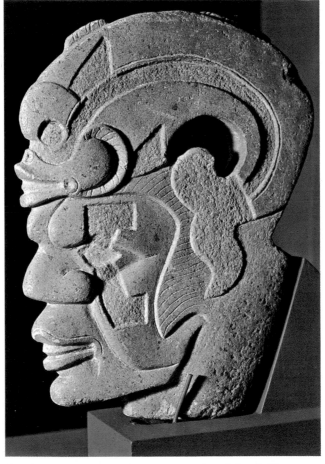

56 *Mexican art, Vera Cruz culture : Basalt 'axe'. Museo Nacional de Antropología, Mexico City.*

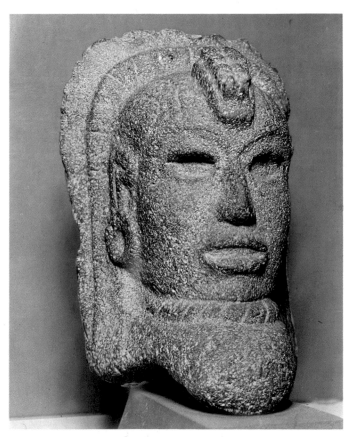

57 *Mexican Vera Cruz culture : 'Palm' motif featuring a
human head. Museo Nacional de Antropología, Mexico City.*

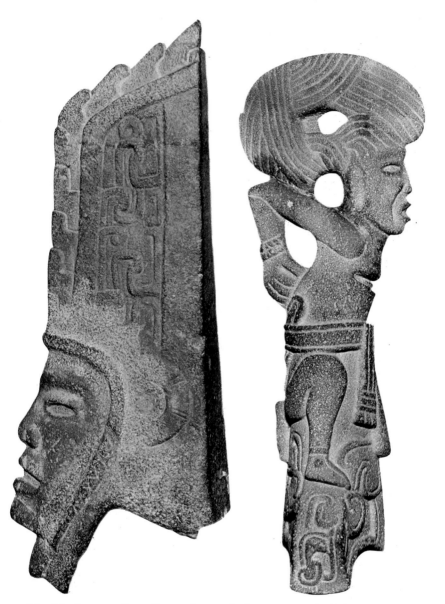

58 *Mexican art, Vera Cruz culture : Anthropomorphic 'palm'. Museo Nacional de Antropología, Mexico City (left). 'Axe' with profile of a male figure. Private Collection, Mexico (right).*

56 Mexican art, Vera Cruz culture: *Basalt 'axe'*. Museo Nacional de Antropología, Mexico City.

'Yokes', 'palms' and so-called 'axes' in the form of flat stone heads with the features depicted in profile.

57 Mexican art, Vera Cruz culture: *'Palm' motif featuring a human head*. Museo Nacional de Antropología, Mexico City.

With the hair neatly caught back behind a crested headdress, an ornament hanging on the forehead, round earrings and a high collar, this face has a classical purity.

58 Mexican art, Vera Cruz culture: *Anthropomorphic 'palm'*. Museo Nacional de Antropología, Mexico City (left). *'Axe' with carved profile of a male figure,* the head made disproportionately large. AD 650–1000. Private Collection.

The 'axe' possibly represents a prisoner: the arms are forced back and there is a deep wound on the chest.

59 Mexican art, Vera Cruz culture: *The Pyramid of the Niches at El Tajin*. 2nd–3rd century AD.

The seven-tiered Pyramid of El Tajin is a remarkable monument and has 365 niches, supposedly one for each of the gods ruling one day in the year.

60 Mexican art, Vera Cruz culture: *Head of a man, from Remojadas*. Museum of Primitive Art, New York.

This small head decorated with bitumen shows a concern for naturalism common to the later Remojadas figures.

61 Mexican art, Huaxtec culture: *Standing figure of a young man*. Museo Nacional de Antropología, Mexico City.

This figure, with its expressive head, rigid and solemn pose and lightly incised body decoration is one of the most interesting examples of Huaxtec sculpture.

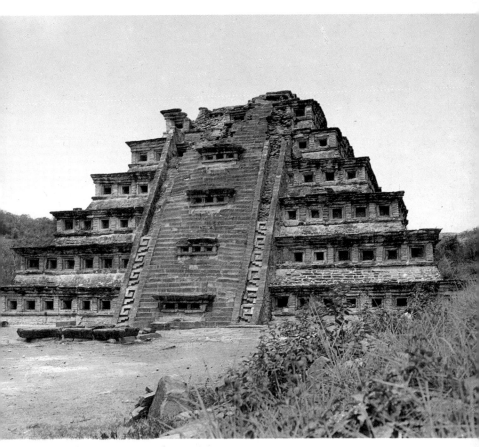

59 *Mexican art, Vera Cruz culture: The Pyramid of the Niches at El Tajin. 2nd–3rd century AD.*

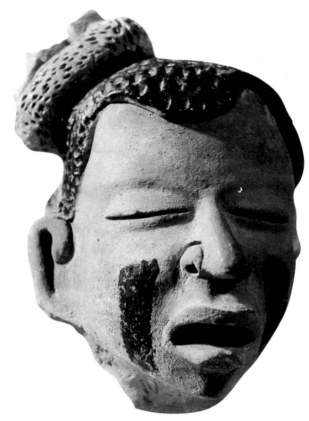

60 *Mexican art, Vera Cruz culture : Head of a man, from*
Remojadas. Museum of Primitive Art, New York.

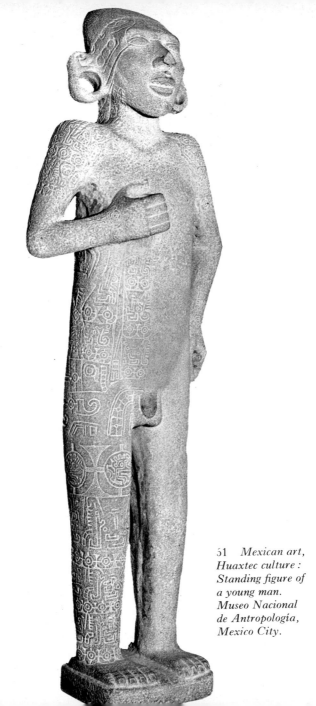

51 *Mexican art,
Huaxtec culture :
Standing figure of
a young man.
Museo Nacional
de Antropología,
Mexico City.*

Mexico City (see illustration 55) is a fine example of Zapotec inspiration: it is made up of twenty-five separate pieces forming the face of the bat-god, with white shell eyes and teeth.

Many funerary monuments were made in a third phase of Monte Albán culture. These show a combination of the local style and elements of Teotihuacan culture. The same is true of the urns, which are increasingly ornate and clearly show the influence of Maya style. At the end of this third phase Monte Albán culture clearly began to decline; from then on their output never rose above the level of craftsmanship. Finally the expansionist policy of the Mixtecs towards the end of the eleventh century led to the end of Zapotec rule in Monte Albán.

The Vera Cruz Region

The Gulf Coast is a rich and fertile area and was once the home of an interesting culture of the same name that developed in the regions of Vera Cruz and Huaxtec. Its finest works of art are in stone and terracotta. The variety of objects and figures represented and their obvious symbolic significance, also the vigour and rhythm of their style reveal much about the rites and ceremonies of these peoples, and the vivacity and imagination of their artists. Three of the most common forms of stone carving, known as the 'yoke', the 'axe' and the 'palm' after their respective shapes, were probably connected with a ceremonial ball-game that was widely played at the time. The 'yoke', made of stone, often from porphyry, diorite or

green granite, possibly represents a decoration worn by the ball players; it is similar to a horse's harness collar, about eighteen inches long and finely polished and incised.

Most of the ornamental motifs are inspired by animal forms – the toad, the two-headed snake and the jaguar; the human body appears less often. A meander pattern of apparently symbolic significance that had been an element of Olmec art recurs frequently. But the 'axe', and particularly its purpose, is a more mysterious matter. These were probably not so much axes as flat stone heads and they usually have engravings on both sides, so that they look like human heads in profile; they may have shown the image of a god or of a man deified after death. The size of the head varies, and may be quite large and rounded, occasionally surmounted by an animal – a fish, a pelican or a bird – that pecks at the skull it stands on. The 'palm', in limestone or granite, is like an oar that broadens like a fan at the end and has a triangular base; the upper part is curved and has a sharp edge. The stone is engraved with a meander pattern; sometimes the whole 'palm' represents a human or animal head or body carved in harmonious lines and elegant symmetry; others end with an indented edge like a feather fan.

The most common deities were usually modelled in terracotta according to popular imagery: the fire-god, for example, has a thin, lined face and carries a heavy brazier on his shoulders; Xochipilli, the liberal god of happiness and flowers, appears as a smiling child; Chalchiuchihuate, goddess of fertility, is serene-

looking and she is portrayed seated to receive offerings. Another type of figurine is the 'Smiling Face', named after the characteristic triangular face that usually features a radiant smile and slanting eyes.

In the State of Vera Cruz the Remojadas area is known for its numerous ceramics, including portrait vases and small figures, typically decorated in black with bitumen and probably dating from a Pre-Classical period; and many female figures with a characteristic short cloak that is still in use in that area today. Also in the State of Vera Cruz is the city of El Tajin, famous for its fine archeological remains; the great truncated pyramid of El Tajin, crowned with a temple that has been partly reconstructed in modern times, towers above the other buildings, the palaces and ball courts. These latter were used for a ritual ball-game, in which the ball is thought to have represented the sun and players of the losing team were sacrificed to the sun-god at the end of the game.

Further north along the Gulf Coast there was another artistic centre, in the Huaxtec region. There the earliest figurines and terracottas, which seem by their style to belong to the Pre-Classical period, are technically and aesthetically as fine as any Classical objects, probably under Teotihuacan influence. The greatest art of this area, however, belongs to a later period, about the twelfth and thirteenth centuries AD, during which many rather stylized and geometric stone stelae and large sculptures were made, including an impressive range of stylized human figures.

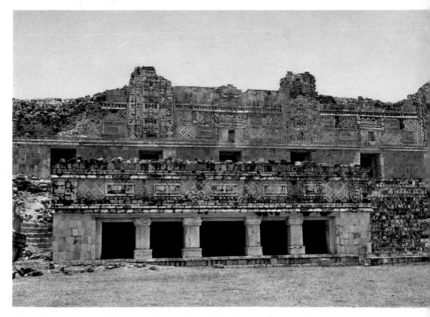

62 Mexican art, Maya culture : Las Monjas at Uxmal, Yucatan.
Classical period.

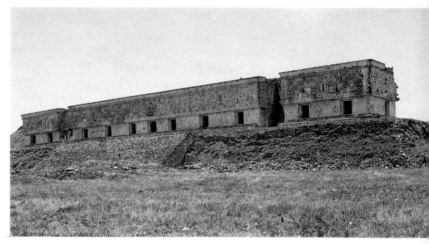

63 Mexican art, Maya culture : The Governor's Palace at Uxmal,
Yucatan. Classical period.

62 Mexican art, Maya culture: *Las Monjas at Uxmal, Yucatan*. Classical period.
Las Monjas consists of a group of four rectangular buildings surrounding a courtyard. Only the upper layer of these classic long low Maya structures is decorated.

63 Mexican art, Maya culture: *The Governor's Palace at Uxmal, Yucatan*. Classical period.
This Palace, built in the same style as Las Monjas, stands on natural terraces; the internal and external walls are decorated with bas-reliefs.

64 Mexican art, Maya culture: *The Palace at Palenque, State of Chiapas*. Classical period.
This is the largest group of buildings at Palenque; they are low and vaulted in Puuc style and are separated by courtyards with walls decorated with fine carved figures.

65 Mexican art, Maya culture: *The Temple of the Sun at Palenque, State of Chiapas*. Classical period.
The Temple of the Sun, together with two temples of similar construction, overlooks the great sacred plaza at Palenque.

66 Mexican art, Maya culture: *The Temple of the Inscriptions at Palenque, State of Chiapas*. Classical period.
This temple is one of the most important examples of Maya architecture, not just for its structure (a great tiered pyramid with a rectangular cella on the summit) but also for the great tomb chamber it encloses, discovered in 1952.

67 Mexican art, Maya culture: *The 'Codz Pop' at Kabah in Yucatan*. Classical period.
A continuous line of masks of Chac (the rain-god) covers the whole façade of the 'Codz Pop' – the name given to it by the natives of Yucatan.

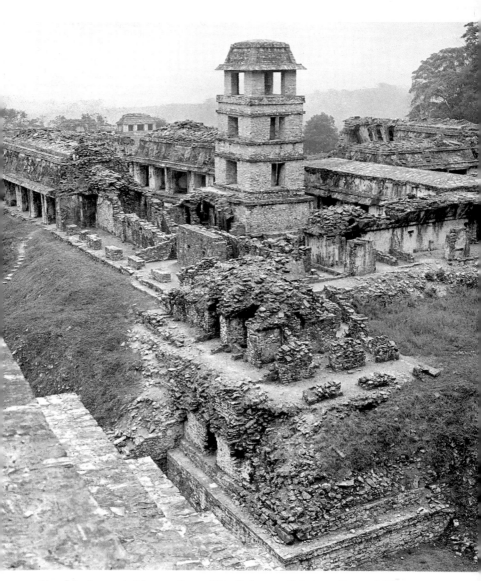

64 *Mexican art, Maya culture : The Palace at Palenque, State of Chiapas.*
Classical period.

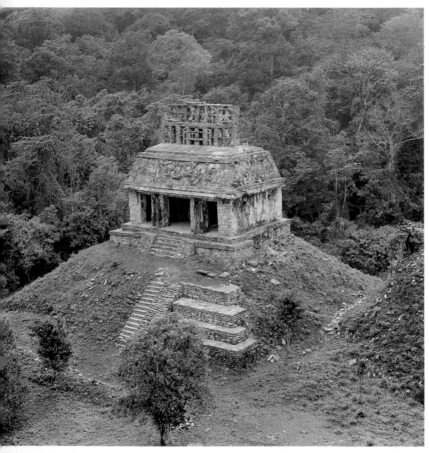

65 *Mexican art, Maya culture : Temple of the Sun at Palenque, State of Chiapas. Classical period.*

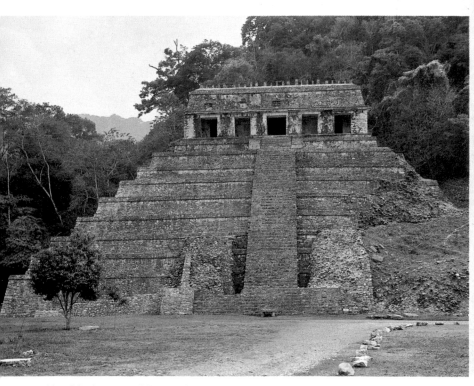

66 *Mexican art, Maya culture : Temple of the Inscriptions at Palenque, State of Chiapas. Classical period.*

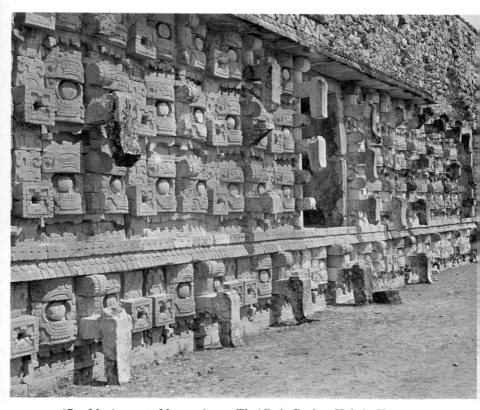

67 *Mexican art, Maya culture : The 'Codz Pop' at Kabah, Yucatan. Classical period.*

Maya Art

Of all the ancient cultures of Pre-Columbian America the Maya is considered the most brilliant for a number of reasons. It spanned a vast period of time – the early Maya developmental phase began in about 1000 BC and the whole culture only declined finally as late as the seventeenth century AD. It extended over a huge geographical area, including the States of Yucatan, Quintana Roo, Campeche, Tabasco, Chiapas, and beyond the limits of Mexico itself to Guatemala, Honduras and El Salvador. Its achievements include the development of a hieroglyphic system of writing and a mathematically computed calendar of great accuracy, all of which more than justifies the enormous amount of research already dedicated to the period.

It was probably in Guatemala that Maya culture took root during its formative Pre-Classical period: the process of its subsequent expansion would be clearer if more Maya writing were decipherable; as it is, only about a third has given up its secrets. The priests were probably the chief source of learning, which they in part shared with members of the highest class. Their religion was no different from others of the same period in Central America, although they worshipped a greater number of gods – one of the most frequent images in all art forms is Chac, the rain-god.

Architecture, painting and sculpture were the three great manifestations of Maya art. Their architecture has a basic form probably derived from the primitive rectangular hut with low walls and a high sloping roof. A characteristic element is the corbelled arch, also

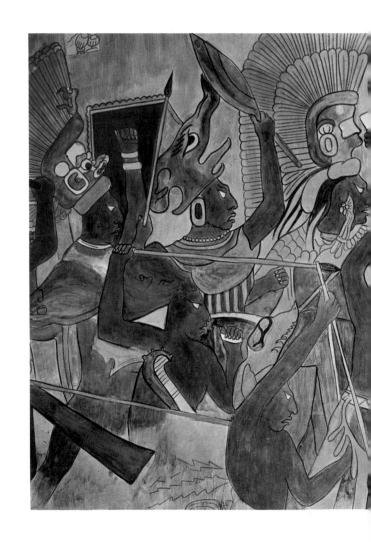

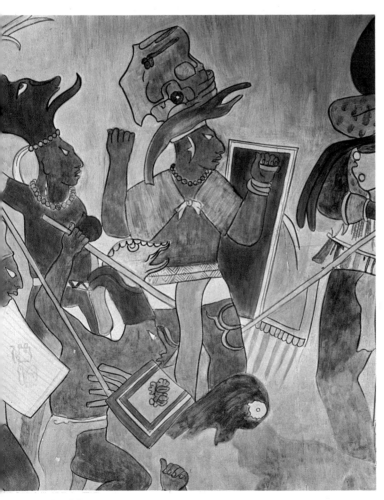

68 *Mexican art, Maya culture : Frescoes from Room 2 of the*
Temple of paintings at Bonampak, State of Chiapas. 6th–9th
century AD. Museo Nacional de Antropología, Mexico City.

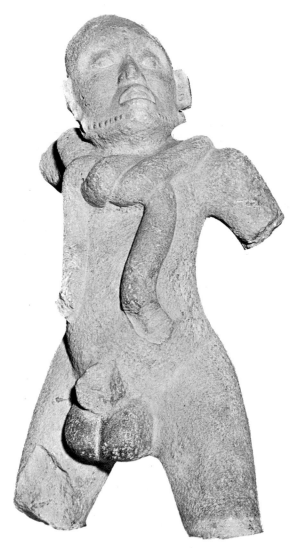

69 *Mexican art, Maya culture : Limestone virility-god.*
Museo Nacional de Antropología, Mexico City.

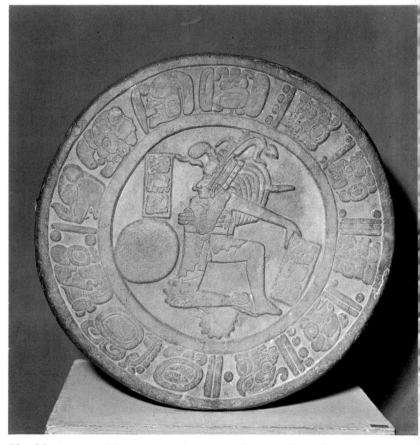

70 *Mexican art, Maya culture : Limestone disc from Chinkultic,*
State of Chiapos. Museo Nacional de Antropología, Mexico City.

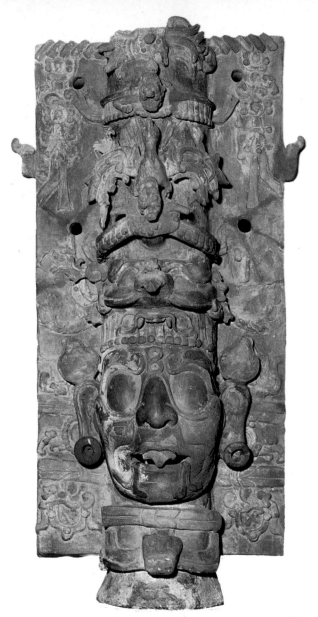

71 *Mexican art, Maya culture : Terracotta tubular vessel with decorations in high-relief. Museo Nacional de Antropología, Mexico City.*

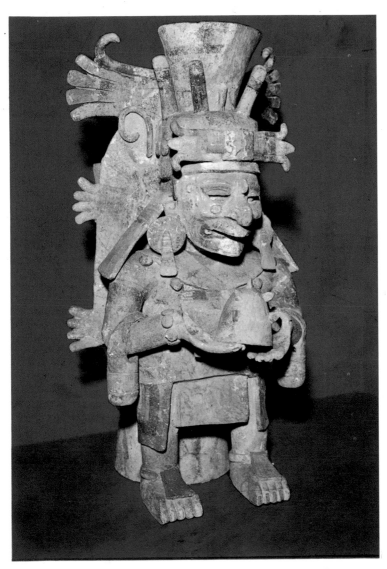

72 *Mexican art, Maya culture : Urn with modelled figure. Museo Nacional de Antropología, Mexico City.*

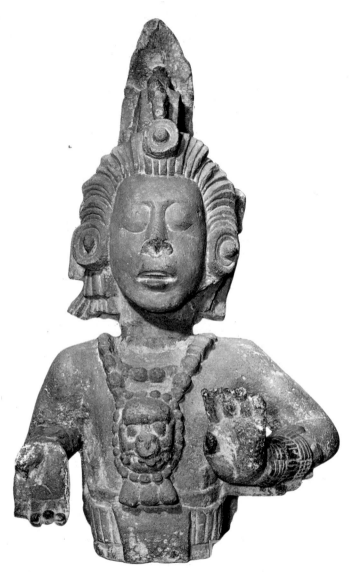

73 *Mexican art, Maya culture : Bust of the maize-god from Copan, Honduras. British Museum, London.*

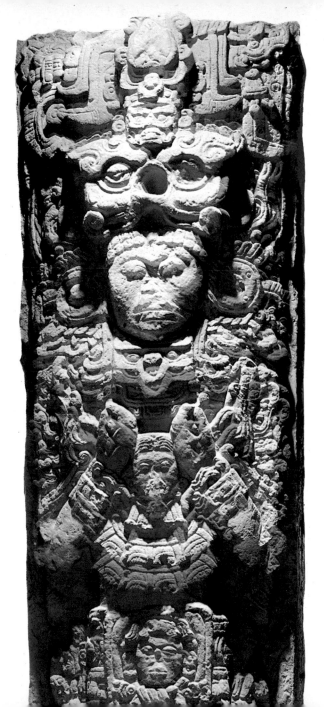

113

68 Mexican art, Maya culture: *Frescoes from Room 2 of the Temple of Paintings at Bonampak, State of Chiapas.* 6th–9th century AD. Museo Nacional de Antropología, Mexico City.

The frescoes of Bonampak, discovered in 1945, are the most important mural paintings in Pre-Columbian America. They cover the walls of three rooms and portray preparations for a ritual, warriors (Room 2) and the triumphant return from battle culminating in the sacrifice of the prisoners.

69 Mexican art, Maya culture: *Limestone virility-god.* Museo Nacional de Antropología, Mexico City.
Although its chief member is lost, the suggestive power of this work remains quite obvious.

70 Mexican art, Maya culture: *Limestone disc from Chinkultic, State of Chiapas.* Museo Nacional de Antropología, Mexico City.
This disc is thought to have served as a stone marker for a ball-game. The player in the centre wears a ceremonial feathered headdress and a leg-guard.

71–2 Mexican art, Maya culture: *Terracotta tubular vessel with decorations in high-relief* (left) and *urn with modelled figure* (right). Museo Nacional de Antropología, Mexico City.
The tubular vessel features a relief carving of the sun-god.

73–4 Mexican art, Maya culture: *Bust of the maize-god from Copan, Honduras.* British Museum, London (left). *Detail of a carved stele.* Museo Nacional de Antropología, Mexico City (right).
Maya stelae are often highly impressive works, carved on either the front only or on all four sides.

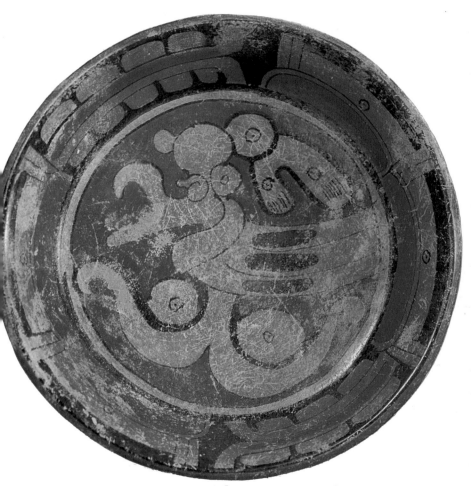

75 *Mexican art, Maya culture : Polychrome ceramic plate. Private Collection, Milan.*

called the 'false' arch, elliptical in shape and constructed by placing each successive block of stone so that it projected beyond the ones below, and was held in position by the weight of the superstructure. Maya buildings have two main forms: a pyramid with superimposed terraces and a long, low building standing on a rectangular base. Stone, wood and lime for the plasterwork were the most usual building materials used, while stucco was widely used for external decoration. The most interesting architectural remains can be seen at the cities of Uxmal, Kabah and Labna in Yucatan; Coba in Quintana Roo; Rio Bec in Campeche; Palenque, Yaxchilan, Bonina and Bonampak in Chiapas; Uaxactun and Tikal in Guatemala and Copan in Honduras.

In general the fresco is the most usual form of Maya painting, and was used either to decorate buildings, for ceramic ornamentation or to illustrate manuscripts. Brilliant and vivid blue is a typical Maya colour; green, red-brown and pink were also popular, and black was often used to outline figures. A fine example of Classical painting are the frescoes at Bonampak in the State of Chiapas, which might have been executed any time between AD 540 and 800. These almost completely cover the interior walls of a building measuring about fifty feet by twelve feet and subdivided into three separate rooms with vaulted ceilings. Each fresco is arranged in three large horizontal sections. The first room is decorated with scenes from Maya ceremonial, such as the robing of the priests and a ritual dance by masked men; the frescoes

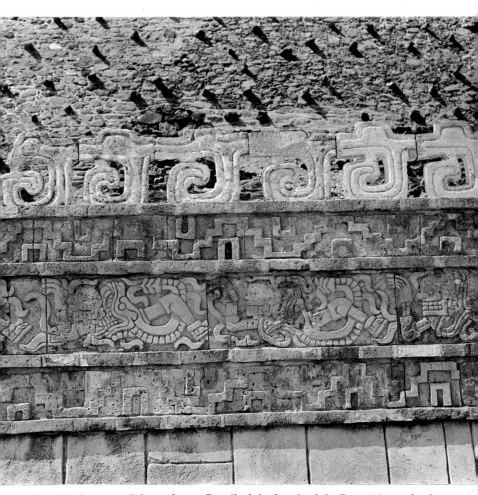

76 *Mexican art, Toltec culture : Detail of the façade of the Pyramid-temple of Quetzalcoatl at Tollan, State of Hidalgo.*

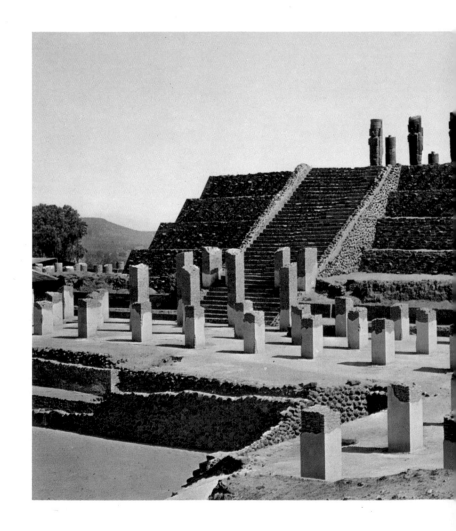

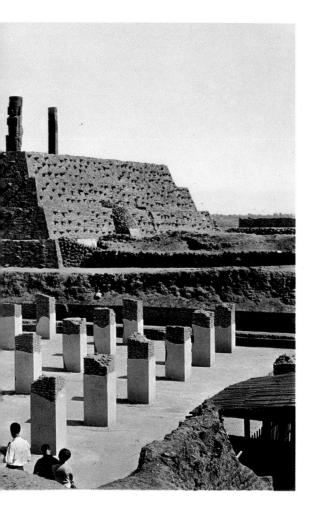

77 *Mexican art,*
Toltec culture :
Pyramid-temple of
Quetzalcoatl at
Tollan, State of
Hidalgo.

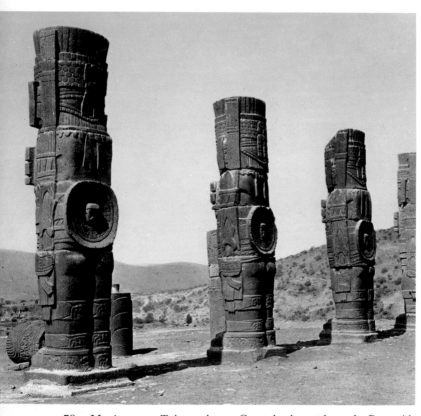

78 *Mexican art, Toltec culture : Carved columns from the Pyramid-temple of Quetzalcoatl at Tollan, State of Hidalgo.*

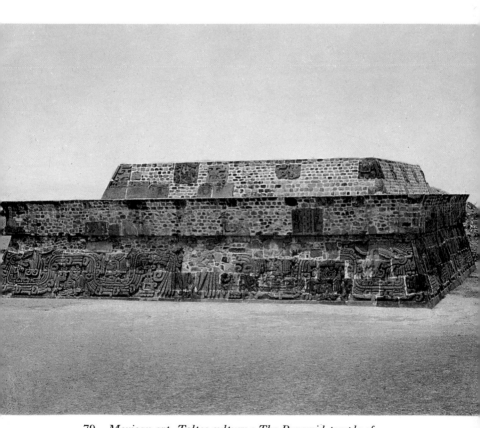

79 *Mexican art, Toltec culture : The Pyramid-temple of
Xochicalco, State of Morelos.*

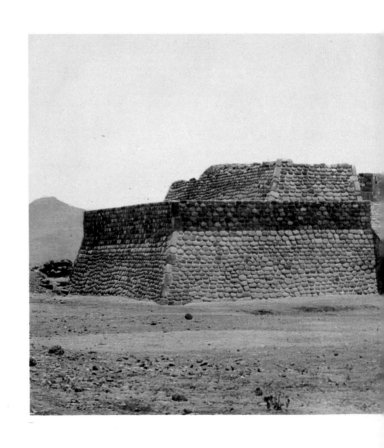

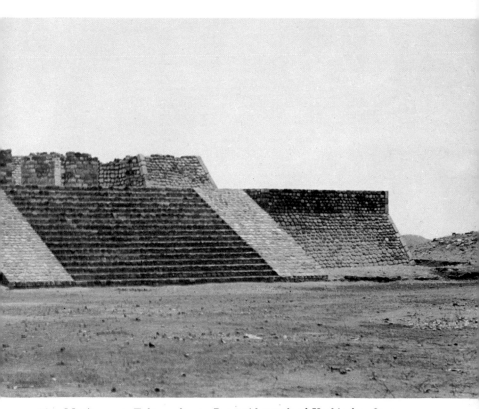

80 *Mexican art, Toltec culture : Pyramid-temple of Xochicalco, State of Morelos (reconstruction).*

75 Mexican art, Maya culture: *Polychrome ceramic plate.*
Private Collection, Milan.
Some of the most beautiful examples of Maya ceramic art
come from Peten, Sierra de Chama, and Nebay in Guate-
mala.

76 Mexican art, Toltec culture: *Detail of the façade of
the Pyramid-temple of Quetzalcoatl at Tollan, State of
Hidalgo.*
Toltec sculptural work is usually original and vigorous
and includes fine bas-reliefs and large-scale figures out-
standing for their power and technical perfection.

77 Mexican art, Toltec culture: *The Pyramid-temple of
Quetzalcoatl at Tollan, State of Hidalgo.*
The Temple of Quetzalcoatl, the god of the Morning Star,
rises from a pyramid of five high terraces, each of which
is decorated with a carved frieze representing the god.

78 Mexican art, Toltec culture: *Carved columns from
the Pyramid-temple of Quetzalcoatl at Tollan, State of
Hidalgo.*
These monumental figures formerly supported the temple
roof.

79 Mexican art, Toltec culture: *The Pyramid-temple of
Xochicalco, after restoration.* State of Morelos.
The archaeological finds at Xochicalco demonstrate the
transitional style that occurred between Teotihuacan and
Tollan cultures.

80 Mexican art, Toltec culture: *The Pyramid-temple of
Xochicalco, State of Morelos (reconstruction).*
A broad staircase leads up to the quadrangular platform
that bears the remains of the temple walls.

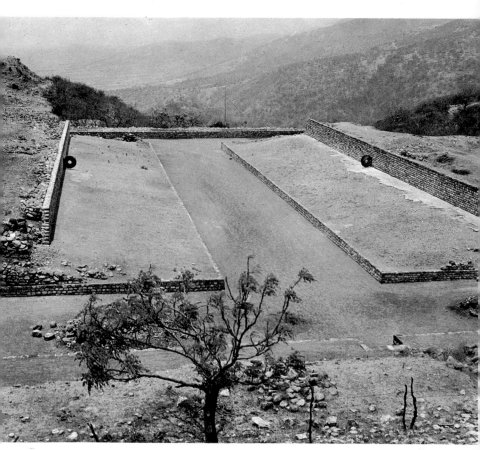

81 *Mexican art, Toltec culture : Ball court at Xochicalco, State of Morelos.*

of the second room illustrate a battle scene in the jungle and show the triumph of the Maya warriors with their prisoners; and the third room shows a ritual sacrifice attended by a great crowd of dancers. All these scenes are reproduced with great vividness, the figures are imposing and highly expressive and their costumes are richly depicted in great detail.

While Maya painting consists mainly of frescoes, their sculpture is usually in bas-relief, although there are also important examples in the round from the Classical period. The materials used range from stone and stucco to clay and wood; colour was of great importance and nearly all Maya statuary was painted, red and blue being the predominant colours. The most frequent subject is the human figure and the development of Maya style can be traced through the changing treatment of the body. In early works it is shown frontally with the head and legs in profile. The gradual development to a more natural position, an increasing care for detail and the introduction of complicated decorative motifs mark successive stages in the evolution of Maya sculpture. Among the finest bas-reliefs are those at Palenque, especially the stone sarcophagus slab in the burial chamber of the Temple of the Inscriptions, and the stelae of Yaxchilan and Copan in Honduras. Stucco reliefs were normally designed to decorate buildings; the best examples of this technique are at Palenque and in the surrounding area. Also in the Temple of the Inscriptions at Palenque, two strikingly naturalistic stucco heads were found that are today considered among the finest examples

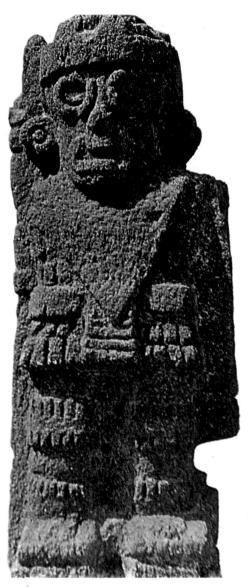

82 *Mexican art, Toltec culture : Stone figure of a warrior.*
Teotihuacan.

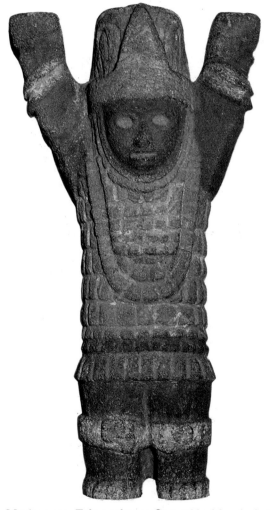

83 *Mexican art, Toltec culture : Caryatid with raised arms.*
Museo Nacional de Antropología, Mexico City.

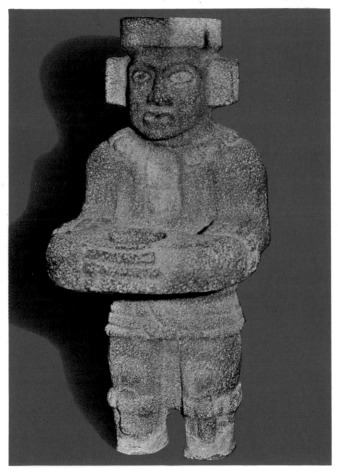

84 *Mexican art, Toltec culture : Stone warrior. Museo de Tula.*

81 Mexican art, Toltec culture: *Ball court at Xochicalco, State of Morelos.*
The walls round the ball court slope inwards in Zapotec, Totonac and Maya architecture, but are perpendicular to the ground in Mixtec, Aztec and Toltec versions.

82 Mexican art, Toltec culture: *Stone figure of a Warrior, Teotihuacan.*
The facial features of the warrior are emphasized to increase the impression of power and strength.

83–4 Mexican art, Toltec culture: *Caryatid with raised arms.* Museo Nacional de Antropología, Mexico City (left). *Stone Warrior.* Museo de Tula (right).
The combinations of colours give these and other examples of Toltec sculpture a pleasing variety, relieving the geometric austerity of their basic forms.

85 Mexican art, Toltec culture: *Cylindrical vase decorated with bas-relief.* Museum für Völkerkunde, Vienna.
The complex motif on this simple vase shape is emphasized by means of a lighter background.

86 Mexican art, Maya-Toltec culture: *The Throne of the Red Jaguar* (copy). Museo Nacional de Antropología, Mexico City.
The original throne was found in the Castillo at Chichen Itza. The spotted coat of the jaguar is suggested by sixty-three jade discs inlaid in the stone; the eyes are made of jade spheres.

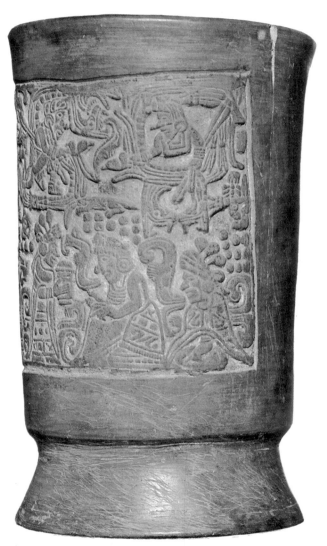

85 *Mexican art, Toltec culture : Cylindrical vase decorated
with bas-relief. Museum für Völkerkunde, Vienna.*

of Maya art. Palenque is indeed a fabulous jungle city, and much of it remains to be explored.

Maya pottery is modelled with great skill and command of technique: the products of this skill include huge anthropomorphic urns decorated with elaborate ornamental motifs and small clay figures, made sometimes from casts, that represent well-known characters from the daily life of the time. Another activity centred round making vases in simple shapes; these were painted in one colour, except in the central Maya region where a polychrome ceramic style developed using geometric motifs, and later a series of naturalistic designs of outstanding artistic quality.

The Classical period ended in this region between the tenth and eleventh century AD with the invasion of a foreign people, the Toltecs, who wrought great changes in Maya art and society. These changes led to the development of a new Maya-Toltec culture.

Toltec Art

For reasons that remain obscure to the present-day observer, the great civilizations like those of Teotihuacan, Monte Albán and the Maya declined at roughly the same time between the seventh and eighth centuries AD. The great religious centres were abruptly destroyed and abandoned, and the politico-economic crisis was reflected in a sharp decline in the standard of their art. In the meantime groups of nomadic hunters came down from the north, and this migration turned into a real invasion. They were called the Chichimechi, and they spread all over the central

plateau of Mexico, forcing the inhabitants to abandon their cities and seek refuge in the south. Later the co-existence of the conquerors and the original inhabitants created new social groups that developed their own individual characters in the course of time. It is believed that the Toltec people came together in this way and then, thanks to the strength of their military leadership, managed by the ninth or tenth century AD to spread their culture throughout an area comprised now of the States of Tlaxcala, Hidalgo, Morelos, Puebla, Sinaloa, Yucatan and Chiapas.

Sculpture and architecture represent the finest expressions of Toltec art: the remains of Tollan, the Toltec religious centre, are a most valuable source of evidence, especially with the discovery of the Temple of the Morning Star or Quetzalcoatl, so-called because of the bas-reliefs of this famous figure, who was deified by local traditions. (Quetzalcoatl, the 'Feathered Serpent', was the son of a Toltec leader who was said to have given his people such a high level of civilization that the very name of Toltec became synonymous with that of an artist and cultured man.) A great pyramid of five stages forms the base of the temple; each stage, the first of which is 129 feet broad, has a frieze of Quetzalcoatl, shown symbolically as a human face between the open jaws of a feathered monster. The monster has a jaguar's body and a serpent's forked tongue. On either side birds of prey hold human hearts in their claws, and along the upper portion of the frieze runs a succession of jaguars and coyotes in bas-relief. An entrance, featuring great columns shaped

like the feathered serpent, and a cella make up the temple itself; the roof is supported by two great wooden architraves which rest on eight pillars about fifteen feet high, carved to represent Toltec warriors equipped for battle. They are constructed with four great tenoned stone drums and are extraordinarily impressive and dynamic in spite of their purely functional character and rough finish. These pillars also show the characteristic Toltec preference in stonework for bas-reliefs rather than sculpture in the round. Very few other statues have been found, but there are some interesting standard-bearers – standing warriors with arms outstretched as if they were holding a standard – a jaguar, and an astonishing basalt statue of a semi-reclining man who is holding up a great vessel. This figure is usually – inappropriately – referred to as Chac Mool; similar figures have been found elsewhere in the parts of the Maya region that were subjected to Toltec rule, in particular at Chichen Itza. It certainly represents a god, and is more likely Quetzalcoatl himself in the guise of 'the one who went away and will rise again to reign once more'.

Toltec sculptures, bas-reliefs and buildings were often partly painted in combinations of red, pink, blue, green, white, ochre and black – which must have relieved the austerity of these massive geometric forms. This severity contrasts vividly with the ornate and decadent style of the late Classical period.

Ceramics were of minor importance in Toltec art, although some lovely vases were made in 'plumbate' ware, so-called because of their glazed enamel or

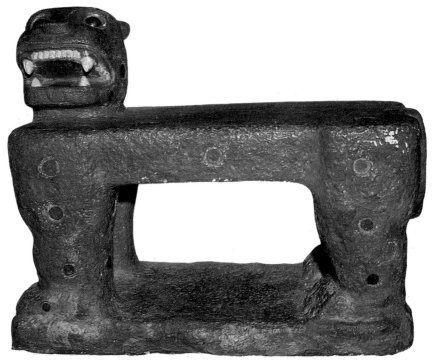

86 *Mexican art, Maya-Toltec culture : The Throne of the Red Jaguar
(copy). Museo Nacional de Antropología, Mexico City.*

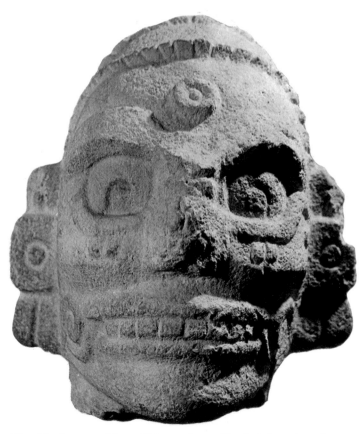

87 *Mexican art, Maya-Toltec culture : Head of the rain-god
Tlaloc. Museum of Primitive Art, New York.*

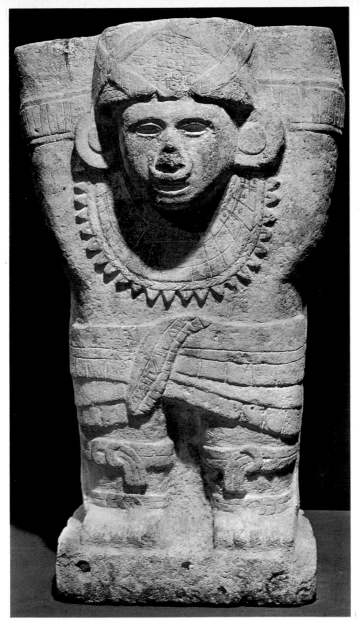

88 *Mexican art, Maya-Toltec culture : Architectural stone carving from Chichen Itza. Museo Nacional de Antropología, Mexico City.*

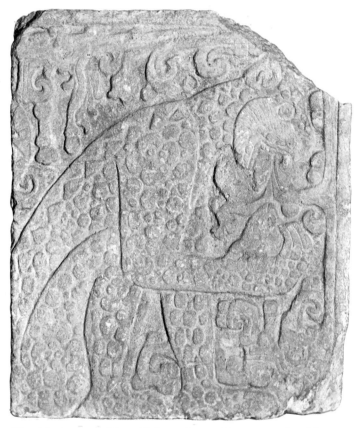

89 *Mexican art, Maya-Toltec culture : Limestone stele with bas-reliefs. Museo Nacional de Antropología, Mexico City.*

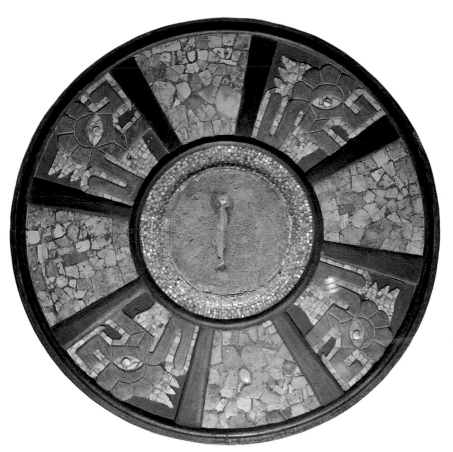

90 *Mexican art, Maya-Toltec culture : Miniature decorative shield, from
Chichen Itza. Museo Nacional de Antropología, Mexico City.*

87 Mexican art, Maya-Toltec culture: *Head of the rain-god Tlaloc*. Museum of Primitive Art, New York.
Tlaloc, the god of springs and rain, is shown in various forms, but the most common is a black figure with a crown of white and green feathers.

88 Mexican art, Maya-Toltec culture: *Architectural stone carving from Chichen Itza*. Museo Nacional de Antropología, Mexico City.
The human characteristics of this block-shaped figure are chiefly brought out via the garments and headdress, which are finely detailed.

89 Mexican art, Maya-Toltec culture: *Limestone stele with bas-reliefs*. Museo Nacional de Antropología, Mexico City.
A crouching jaguar holds a human heart between his claws. Human sacrifice is a theme regularly portrayed in Toltec art and is often found on stelae and temple reliefs.

90 Mexican art, Maya-Toltec culture: *Miniature decorative shield from Chichen Itza*. Museo Nacional de Antropología, Mexico City.
This shield is decorated with eight turquoise mosaics in an alternating sequence of motifs.

91 Mexican art, Maya-Toltec culture: *Gold figure from Chichen Itza*. Museo Nacional de Antropología, Mexico City.
This is quite roughly-made gold work – though the headdress shows some attention to detail.

92 Mexican art, Maya-Toltec culture: *'La Iglesia' at Chichen Itza in Yucatan*.
The use of repeated motifs adds to the grandeur of this fairly small-scale building.

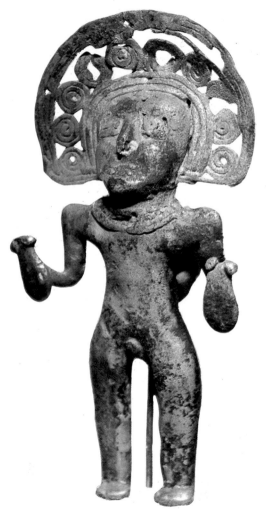

91 *Mexican art, Maya-Toltec culture : Gold figure from Chichen Itza. Museo Nacional de Antropología, Mexico City.*

cloisonné finish, shaped in various human and animal forms. Other interesting examples are the goblets and tripod vessels of the 'orange' ware range; these were often decorated with black engraving or painting.

Maya-Toltec Culture

At some time around AD 1000 the Itza people, a part of the Toltec race, descended on Maya territory and conquered the local population. They extended their control over Yucatan and the highlands of Guatemala, and thus Maya-Toltec culture was born. Although it was perhaps inferior aesthetically and spiritually to the Classical Maya period it still produced many objects of fine quality. The city of Chichen, now called Chichen Itza after its conquerors, was the cultural and artistic centre of this civilization and the stronghold of Toltec rule in the country. The Toltecs introduced many stylistic elements in Chichen from Tollan (later known as Tula); these infused the then decadent Maya art with new ideals of strength and severity. It is also believed that the Toltec conquest was followed by a gradual synthesis of the two cultures, since the art of the time shows no trace of the brutal change in style that sometimes marks the imposition of a conquering people's art in their newly-acquired territories.

At Chichen Itza the Toltec stylistic elements resulting from the fusion with Maya art are particularly obvious in the use of columns to support the beam roofs, and in the design of circular-based temples with serpent-shaped columns at their entrances. The jaguar motif is a common decorative element as are the feathered ser-

pent and the bird of prey holding a human heart in its claws, and fresco paintings showing Toltec rituals of human sacrifice.

Stone sculpture included the figures of the standard-bearer, the large anthropomorphic figures and more frequently the Chac Mool. In the sacred Well of Sacrifice – a natural well in the northern part of the city – were found many offerings of gold, copper, jade, terracotta, wood and even woven objects; these included some very beautiful necklaces, rings, pectorals and ear-rings, masks and gold discs decorated with scenes of human sacrifices and battles in elegant and simple lines. Some of the objects, especially those in gold, came from other parts of Central and South America, such as Panama and Colombia, and so prove that relationships existed at this time with other and far-off cultures.

It was only in 1923 that excavations were started at Chichen Itza that brought to light evidence of the Maya-Toltec cultural phase. This phase itself probably occurred between the eleventh and twelfth centuries AD. Nearly all the most important constructions at Chichen Itza date from the period of Toltec invasion: they include El Castillo, the Temple of the Warriors and the Court of the Thousand Columns. The Castillo is a pyramid built in nine stages, with staircases leading up each of the four sides to a low temple on the summit. Inside the Castillo another pyramid has been found, which has survived undamaged because of its outer protection; it too is crowned with a temple. Two important stone sculp-

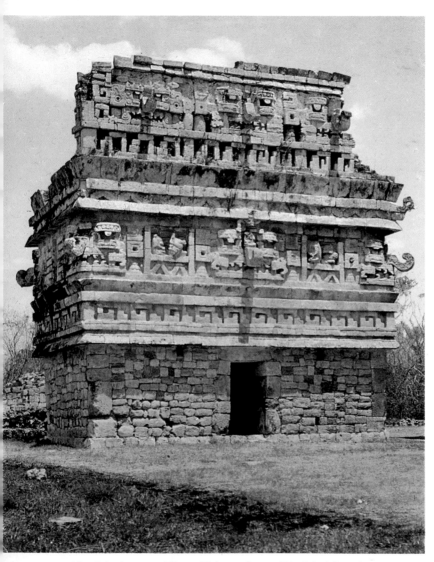

92 *Mexican art, Maya-Toltec culture: 'La Iglesia' at Chichen Itza, Yucatan.*

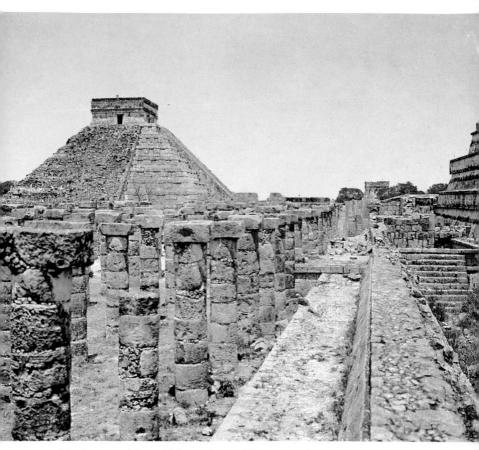

93 *Mexican art, Maya-Toltec culture : The Court of the Thousand Columns at Chichen Itza, Yucatan.*

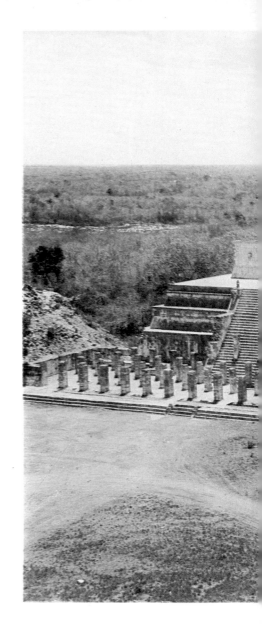

94 *Mexican art,*
Maya-Toltec
culture : The Temple
of the Warriors at
Chichen Itza,
Yucatan.

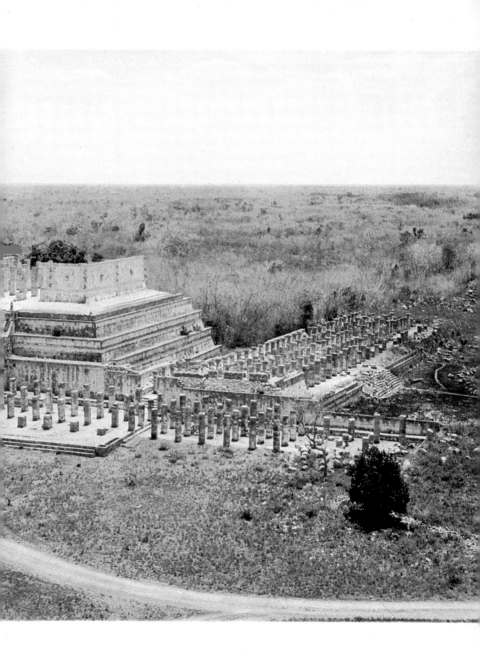

95 *Mexican art, Maya-Toltec culture : The Great Ball Court and Temple of the Jaguars at Chichen Itza, Yucatan.*

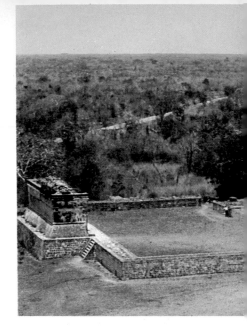

96 *Mexican art, Maya-Toltec culture : The Caracol at Chichen Itza, Yucatan.*

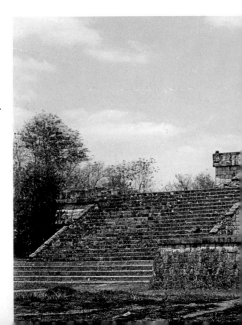

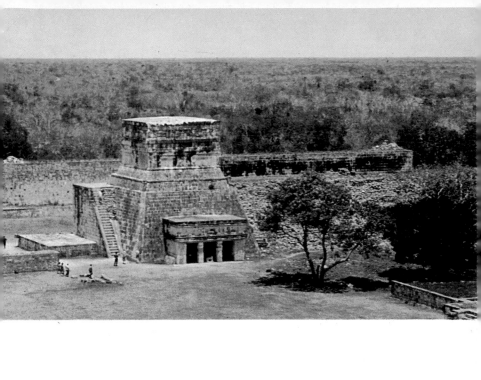

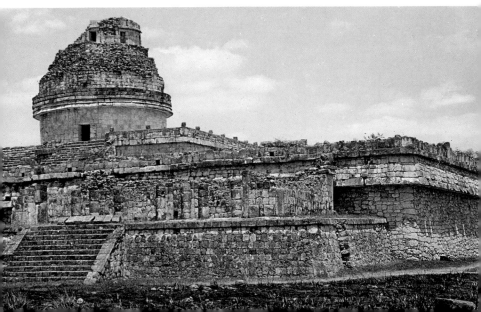

93　Mexican art, Maya-Toltec culture: *The Court of the Thousand Columns at Chichen Itza, Yucatan.*
This impressive court stands beside the Temple of the Warriors. In the background is the Castillo, a nine-stage pyramid built over an earlier pyramid.

94　Mexican art, Maya-Toltec culture: *Temple of the Warriors at Chichen Itza, Yucatan.*
This temple is built in typical Toltec style: like the Castillo it also encloses another pyramid, known as the Temple of Chac Mool.

95　Mexican art, Maya-Toltec culture: *The great Ball court and the Temple of the Jaguars at Chichen Itza, Yucatan.*
This is the most impressive of the seven ball courts at Chichen Itza. The Temple of the Jaguars rises majestically to one side of the court.

96　Mexican art, Maya-Toltec culture: *The Caracol at Chichen Itza, Yucatan.*
The Caracol was used as an astronomical observatory: apertures in the exterior walls received the rays of the sun only at certain specific times of the year, and by registering these moments alone a variety of calendrical and cosmological ideas could be formulated.

97　Mexican art, Maya-Toltec culture: *Skull platform at Chichen Itza, Yucatan* (detail).
Lines of skull carvings form the chief decoration of this platform, on which were stored the impaled heads of sacrificial victims.

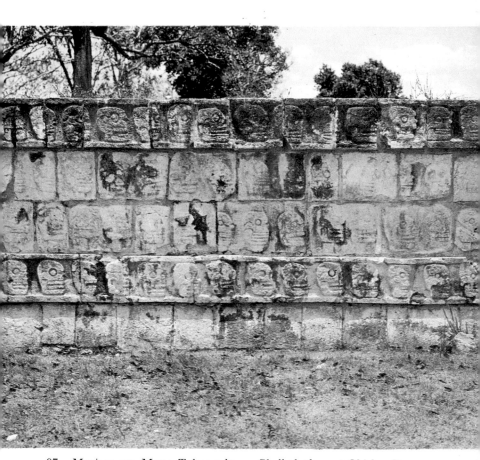

97 *Mexican art, Maya-Toltec culture : Skull platform at Chichen Itza,*
Yucatan (detail).

tures were discovered there: a Chac Mool in the entrance, and a superb Red Jaguar throne, which was in the cella. This must have been the Sun Throne, since a wooden disc inlaid with turquoises and representing the sun, was found over it.

The Temple of the Warriors is structurally similar to the Temple of Quetzalcoatl at Tollan. It stands on the summit of a low, broad pyramid of five stages, decorated with bas-relief friezes. The internal walls of the cellas of the Temple are decorated with alternating masks of Chac, the Maya rain-god, and figures of Quetzalcoatl in the symbolic Toltec form of the feathered serpent-man. Like the Castillo the Temple of the Warriors encloses another pyramid – called the Temple of Chac Mool because a statue of Chac Mool was found inside. In front of the main façade of the Temple of the Warriors is the Room of the Thousand Columns, a great rectangular-shaped area from which rise sixty square carved columns. Another vast area of columns is the Courtyard of the Thousand Columns, where six hundred columns surround a huge plaza. Other impressive buildings making up the city of Chichen Itza are the Temple of the Jaguars, named after the friezes decorating its external walls, and which has really outstanding frescoes in its cella, and the Caracol, a massive helicoid tower. The word *caracol* means conch shell, and derives here from the winding internal staircase leading to the upper storey; the building was used as an astronomical observatory. Also in Toltec style is a platform decorated with bas-reliefs of human skulls – once a rack for the stakes on

which the heads of human victims were impaled. Also in Chichen Itza are seven ball courts: the largest has bas-reliefs on its perimeter walls, and the most famous of these shows a recently beheaded player.

Chichen Itza was the Maya-Toltec capital for about three centuries before it was suddenly abandoned in about 1200, probably because of a violent revolt of the local population against the Toltec overlords. A period of decadence then followed, during which the capital was transferred to Mayapan in north-west Yucatan. The city of Mayapan is a much poorer and less elegant copy of Chichen Itza, and that phase of Maya-Toltec culture is of comparatively little interest. The decadence of Maya-Toltec culture was a natural result of frequent warfare and its decline was hastened by a period of internal struggle between the two leading families of Yucatan, the Cocom of Mayapan and the Xiù of Uxmal. This ended in the destruction of Mayapan some time between 1441 and 1460.

Today, of all the vast Maya-Toltec possessions, only Chichen Itza remains a centre of pilgrimage.

BIBLIOGRAPHY

E. C. BAITY, Americans before Columbus, New York **1961**

F. J. DOCKSTADER, Arte indiana in America, Milan **1961**

G. F. EKHOLM, Maya Sculpture in Wood, New York **1964**

H. LEHMANN, L'art précolombien, Paris **1960**

S. K. LOTHROP, Les trésors de l'Amérique précolombienne, Geneva **1964**

S. K. LOTHROP, W. F. FOSHAG, J. MAHLER, Arte precolombiana, Milan **1958**

K. RUPPERT, J. E. S. THOMPSEN, I. PROKOURIAKOFF, Bonampak, Chiapas, México, Washington **1955**

S. TOSCANO, Arte precolombino de México y de la America Central, Mexico **1952**

G. O. TOTTEN, Maya Architecture, New York **1926**

H. TRIMBORN, Le civiltà precolombiane, Rome **1960**

LIST OF ILLUSTRATIONS